As Good as Gold

50 YEARS OF THE MFA AT CLEMSON

CLEMSON MFA PROGRAM
50th Anniversary Art Exhibition

PART I
September 6 – October 31, 2023
Lee Gallery

PART II
September 6 – October 31, 2023
Brooks Center for the Performing Arts

PART III
January 26 – March 8, 2024
Lee Gallery

As Good As Gold: 50 Years of the MFA at Clemson showcases and celebrates the remarkable achievements of an impressive roster of artists who have graduated from Clemson University's Master of Fine Arts (MFA) Visual Arts program. Presented in three installations over the academic year, this milestone exhibition series commemorates the first awarding of an MFA from our program at Clemson in 1973, and features works across five decades spanning a variety of disciplines. Beginning with Jeanet Dreskin, the very first MFA Visual Arts graduate, the exhibition series highlights the work of approximately 70 artist alumni.

Clemson University's Visual Arts MFA program is highly regarded nationally, and teaching within our unique collaborative structure has been one of the most rewarding experiences over my tenure as a faculty member. Our graduate students come from across the nation, and the world, to create artworks using a wide range of media and develop innovative conceptual strategies. Our faculty are internationally distinguished for their research and teaching. The Visual Arts provide a critical lens through which we can see our communities and play a vital role in shaping them. Through half a century, encompassing varied artistic movements and cultural impacts, this exhibition asserts the crucial role that our artist alumni have demonstrated in pushing creative boundaries and shaping meaning at Clemson, and in the greater contemporary art world.

With over 250 MFA Visual Arts alumni, the selection and organization of the exhibition series has been a labor of love, the highest appreciation is due to our Lee Gallery Director, Denise Woodward-Detrich, and juror, Harriett Green, for their pivotal roles, institutional knowledge, and championing of the arts in South Carolina. Special thanks to Clemson University's Graduate School Dean, John Lopes, for his dedicated presence and continuing support of our MFA students, and our newly formed College of Architecture, Art and Construction Interim Dean, George Petersen, for his enthusiasm and encouragement as we

shape the next 50 years of our program. Mike Vatalaro and David Detrich, emeritus faculty, and Graduate Coordinator Kathleen Thum provide reflections on our history and program successes. We also thank the many faculty and alumni who contributed memories, historic information, and images of their current practice to our documentation – it is not too late to join us! We look forward to sharing these with you over the coming year on our website and on social media.

Congratulations to our dedicated and talented MFA alumni over all 50 years. We hope you enjoy this dynamic celebration of their exceptional creative works!

VALERIE ZIMANY
Chair and Professor
Department of Art

TABLE OF CONTENTS

DEAN MESSAGES	2
PROGRAM COORDINATOR COMMENTS	4
JUROR'S REFLECTION	5
HISTORY	7
THE ART	
1970s	11
1980s	17
1990s	29
2000s	43
2010s	65
2020s	87
ARTIST INDEX	91

DEAN MESSAGES

IT'S A GREAT HONOR to be a part of two historic events at Clemson University this year. The first is the founding of the new College of Architecture, Art and Construction, and the second is the 50th anniversary of our Master of Fine Arts program. This pair of events is a perfect example of how continuity can coexist with change.

Before coming to CAAC to serve as interim dean, I had the pleasure of founding and leading the College of Education. I have seen time and again how art enhances student learning, adding a creative dimension to their thinking and engagement in all subject areas that has lifelong benefits. Our MFA program, of course, operates on the highest level of craft and artistry, setting a standard for excellence that not only results in phenomenal works of art by our MFA students but also inspires creativity across our college, the University, and the state.

What began with Jeanet Dreskin 50 years ago has grown into an alumni network of artists that spans the globe and strengthens our state of South Carolina. As we launch a new college, I'm excited to steward and promote the tradition of arts excellence that our MFA program represents.

<div style="text-align:center">

GEORGE J. PETERSEN, Ph.D.
Interim Dean
College of Architecture, Art and Construction

</div>

OUR HEARTIEST CONGRATULATIONS—and thanks—to Clemson's Master of Fine Arts program on 50 years of educating and inspiring its talented students. Albert Einstein knew that "arts and sciences are branches of the same tree," and no graduate education enterprise would be complete without the arts. In a world where the fine arts are too often considered luxuries, we are proud to support Clemson's MFA program.

Over the past five decades, this program has been a beacon of creativity, igniting the imaginations of countless aspiring artists and shaping the artistic landscape at Clemson and beyond. Through its top-notch curriculum, distinguished faculty, and immersive learning, it has consistently produced studio artists, art teachers, professors, administrators, and arts commission contributors who have helped educate and transform the lives of South Carolinians and citizens of the world.

As the program embarks on its next chapter, I have no doubt it will continue to inspire and empower generations of artists, fostering their growth and nurturing their unique voices. Here's to 50 years of artistic expression and to many more years of shaping the state of the arts.

<div align="center">

JOHN M. LOPES, Ph.D.
Associate Provost and Dean
The Graduate School, Clemson University

</div>

PROGRAM COORDINATOR COMMENTS

CELEBRATING THE 50TH ANNIVERSARY of our MFA program in Visual Arts fills me with immense pride and excitement as the newly appointed MFA graduate program coordinator. This milestone allows us to honor and witness the incredible successes of our alumni, achieved over five decades, while also looking forward to the promising future ahead.

Throughout my 10 years of teaching at Clemson, I have developed a deep appreciation for the strength of our MFA program. The high caliber of graduate students we work with, the collaborative teaching of the faculty, and the remarkable artistic and career achievements of our MFA alumni all contribute to the program's enduring excellence. The interplay and exchange of ideas and insights among students and faculty from different disciplines is at the core of what makes our MFA program truly distinctive. Embracing this variety of approaches to art creates a rich and fertile educational environment, nurturing the growth of each student's creative voice and fostering a sense of community along with lasting connections among our students and faculty.

Our past, current and future graduate students are the heart of the Department of Art. Their commitment to artistic practice and academic rigor energizes both faculty and undergraduates. Witnessing the creative and academic accomplishments the graduate students produce during their time in the program is nothing short of inspiring. Equally impressive is the diverse array of artistic careers and creative works our students produce and develop after graduation.

As we celebrate this significant milestone of our MFA program, we will continue to build upon the foundation of excellence laid down by our remarkable alumni over the past 50 years. Together, we will nurture a community of diverse artists and scholars, fostering creativity, collaboration and innovation as we continue to shape the future of visual arts for generations to come.

KATHLEEN THUM
Associate Professor and
MFA Graduate Program Coordinator
Department of Art

THE MOST GRATIFYING EXPERIENCE during my 25-year tenure as MFA graduate program coordinator was having a unique perspective that allowed me to witness the growth and maturity of students when entering the program, compared to their departure when they graduated with their MFA degrees. The strides and accomplishments each student made in their studio practice during this time were extremely rewarding to observe. The sum total of this experience is reflective of the qualities and assets of a truly remarkable program that has produced truly remarkable lifelong learners that continue to make significant contributions to the field of visual arts. I am confident that the art world is certainly a richer place with Clemson MFA graduates participating in it.

DAVID DETRICH
Emeritus Professor of Art and
MFA Graduate Program Coordinator 1997-2022
Department of Art

JUROR'S REFLECTION

THERE WAS THAT MOMENT in the jurying process that gave me a reason to pause and contemplate the purpose and meaning of culling through hundreds of images and making decisions about works to include in the exhibition. It was a moment of reflection about the role of the juror in a process that is often guided by standardized notions of the best works, the most relevant subjects, the most provocative ideas.

It was in that moment of pause where I concluded that showing the arc of creativity generated through Clemson University's MFA program over 50 years was more relevant than showing an allegiance to the standards of jurying to which I had become indoctrinated.

With that realization, I could not simply jury this body of work on merit. After all, each of these artists had earned merit by graduating with an advanced degree from Clemson University. Furthermore, the works submitted for review were unquestionably of high quality and many artists had proven themselves in the academic and art arenas. In the end, what made more sense was to highlight works that conveyed the story of five decades of teaching, learning and practicing.

To embrace my "new" perspective on jurying this exhibition, a discussion with the gallery director was essential. This collaboration led to a three-part exhibition - with two taking place in the fall of 2023 and one in the spring of 2024 - with 71 artists selected from over 300 submissions.

The more than three decades of visits to Clemson University's Art Department - popping in the various studios to check out student works, observing the interaction between teacher and student, attending art openings, lectures, and panel discussions - proved to be an advantage and provided context and somewhat of an insider's state of mind for the jurying process. It was not surprising that during the review I could see the influence of some of the studios and while it was a blind jurying process, many of the works seemed familiar.

The works submitted offered myriad opportunities to configure an exhibition that would become the embodiment of 50 years of the MFA program. Works by established artists whose careers span more than 30 years are distinguishable from those by more recent graduates. Artistic practice reveals a range of approaches from foundational to experimental. Social, political, environmental, and other societal issues populate many of the works. Some artists show a real commitment to the formal elements of art making while others push boundaries.

The influence of some of the professors stood out as a nod to the collaboration between teacher and student that takes place in the teaching studio. However, the influence of professors on their students was eclipsed by my own impulse to effectively select works that I believed would make a strong exhibition. The arc of creativity from 1973 - 2023 is evident in the representation of all the studios in the Department of Art.

Photography provides an opportunity to see a broad range of photographic processes from the handcrafted to processes that employ technology. Subject matter factors greatly in my choices of paintings. In some of these works, I find interesting narratives of time zones, dream logic and cowboys. Works on, of or about paper - prints, drawings, collages - offer a range of styles, subject matter, processes, and techniques in their pure forms and in communion with other media.

Installation art has been around since the 1960s. Its popularity has increased over time to become the art form of choice for many contemporary sculptors including artists in this exhibition. Yet, some sculptures are included for their quiet formal quality while others stand in contrast to convey the sculpture's endless possibilities. This too is true for ceramic works which share similar attributes with the sculptures in this exhibition. The works are formal and quirky, functional, and non-functional. Some show an affinity for figuration and suggest elements of abstraction through expressive qualities.

Together, the collection of works is proof of the impact of the MFA program in providing a good foundation on which students could build professional careers. The exhibition also supports Clemson University Art Department's stature as one of the leading MFA programs in South Carolina and the region. What lies ahead for the next 50 years remains to be seen. However, I am confident that the success of the first 50 years will propel the next 50 years of the MFA program to new heights - perhaps extending the arc of creativity to a full circle.

HARRIETT GREEN
Art Consultant

Harriett Green is a former visual arts director of the South Carolina Arts Commission from 1992-2021 and is currently an art consultant.

HISTORY

**REFLECTIONS ON THE GROWTH
OF THE MFA VISUAL ART PROGRAM
AT CLEMSON UNIVERSITY**

IN 1970, THE MFA VISUAL ARTS PROGRAM at Clemson was created as part of an overall graduate focus for the College of Architecture. Visual studies was established, along with urban planning, construction science, and landscape architecture to join the existing architecture program. Dean Harlan McClure secured a two-year master's program for each department, and the Master of Fine Arts degree was launched. Dean McClure saw the designation of "Visual Studies" to be well-aligned with the School of Architecture, whose undergraduate program benefited from Foundation Design courses taught by the art faculty. At the time, the undergraduate architecture and design degrees fed into the other discipline's master's programs. However, the MFA was intended to attract applications from undergraduate art programs across the state and nation.

Enrollment began with a small group of diverse students with varied backgrounds. The faculty began to identify the needs of each individual student in the areas of expertise they had chosen, as well as refine the collective professional emphasis leading to a written thesis, and, most importantly, the culminating thesis exhibition. There were five studio areas to develop: painting and drawing, printmaking, photography, sculpture and ceramics, and graphic design. The program celebrated its first graduate, Jeanet Dreskin, in 1973.

By 1976 there were students in each area, and sculpture faculty John Acorn was appointed as the chair of the new department. As the incoming ceramics professor, directly out of graduate school myself, I was eager to join the department to advance and develop the MFA program. The timing was important as the South Carolina Arts Commission had just recently been formed, and there was a very encouraging energy to expand the awareness of the visual arts in the state and southeast. The Lee Gallery would join in with exhibition exchanges across the region, exposing new art to our students and community.

The faculty worked to build a studio environment that was challenging and engaging. Acknowledging that students learn so much from each other in a studio setting, the faculty worked hard to bring about a shared exchange between all students and faculty. Several faculty undertook their own studio research side by side with their students, demonstrating the creative process. Faculty conducted midterm and final reviews as a team – critiquing, evaluating, and advising each other's students. This unique approach encouraged a broader crossover among disciplines. Indeed, the selective size and the team-teaching efforts would become a critical strength of the program.

In the program's early years, faculty and students gathered for weekly brown bag lunches. An easy exchange developed, and soon students were sharing their recent work and studio efforts with each other as an offshoot of these casual meetings. The positive energy coalesced into a program they called "Open Studio." Faculty and students

identified a two-hour common time when they would get together and visit students' studios informally, not as an official review but as a sharing of ideas and responses to works in progress. The dialogue reinforced that each studio art discipline has different demands, strengths, and histories, but the modes to investigate, develop, and refine their shared skills were common to all.

The faculty also sought out opportunities to travel with students annually to a major east coast city. Sharing three or four days in New York or Washington, D.C. would provide students significant exposure to great art collections, galleries, and exhibitions. The museum experience brings art history learning alive and contributes to our individual studio experience at home. Both faculty and students benefitted enormously from these field trips and from attendance at the College Art Association, the National Council on Education in the Ceramics Arts (NCECA), Southeast Photography Society, and Southern Graphics Council meetings, providing invaluable introductions and exchange with regional and national artists in the field.

From the earliest years, the graduates of the MFA program maintained a high rate of continuation as professionals in the arts. They were — and continue to be — well-represented in the South Carolina Arts Commission exhibitions, fellowships, awards, and collections, and actively contribute to the professional art community regionally and nationally. The accomplishments of alumni are the program's greatest source of pride over its first 50 years, and we are looking forward to another successful 50 years in the future.

MIKE VATALARO
Emeritus Professor of Art

With gratitude to Emeritus Faculty John Acorn, Sam Wang, and Tom Dimond for their contributions to this history.

MFA faculty and students, circa 1982

Photo courtesy of **Sam WANG**

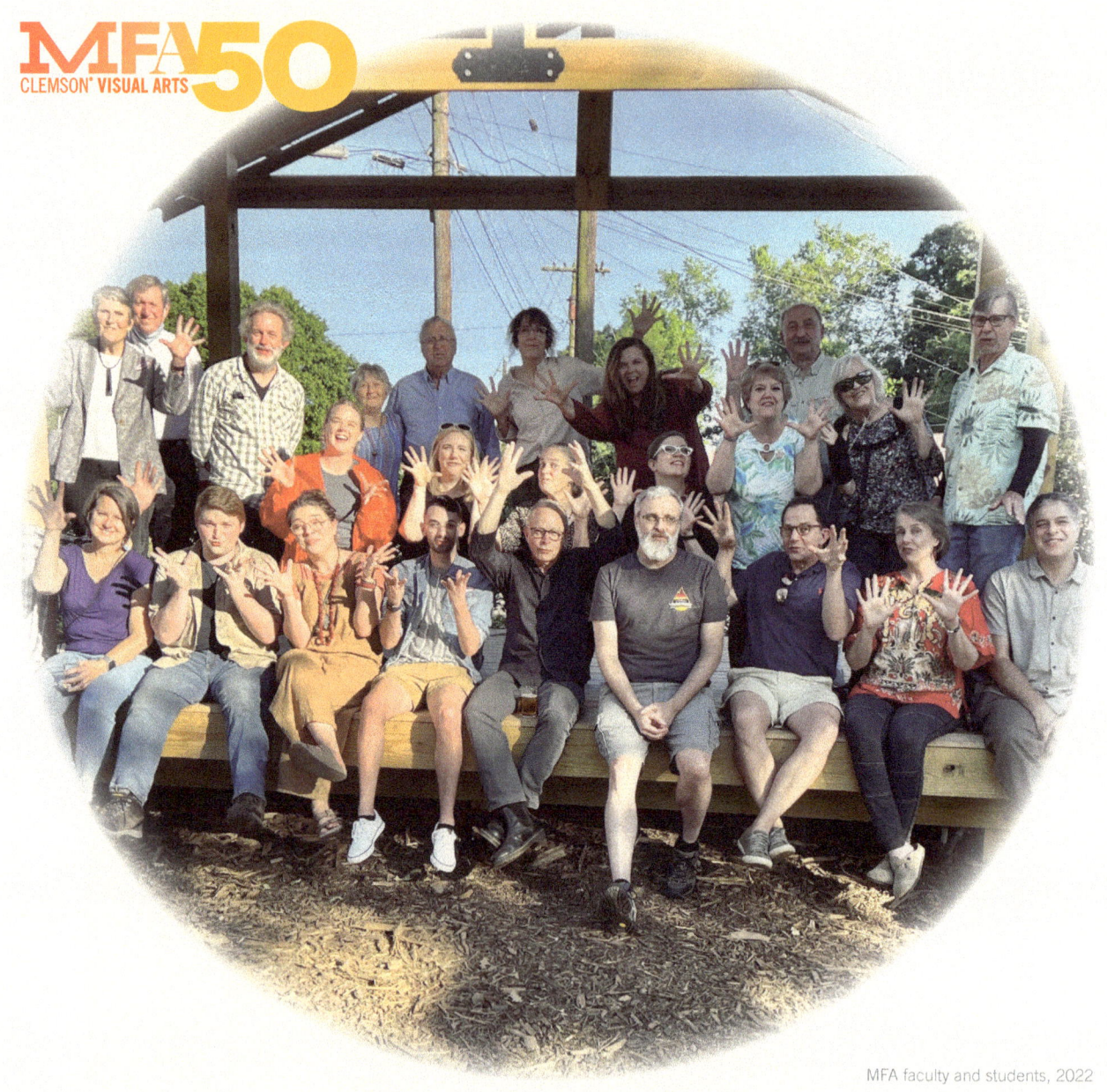

MFA faculty and students, 2022

Photo courtesy of **Meredith MIMS MCTIGUE**

1970s

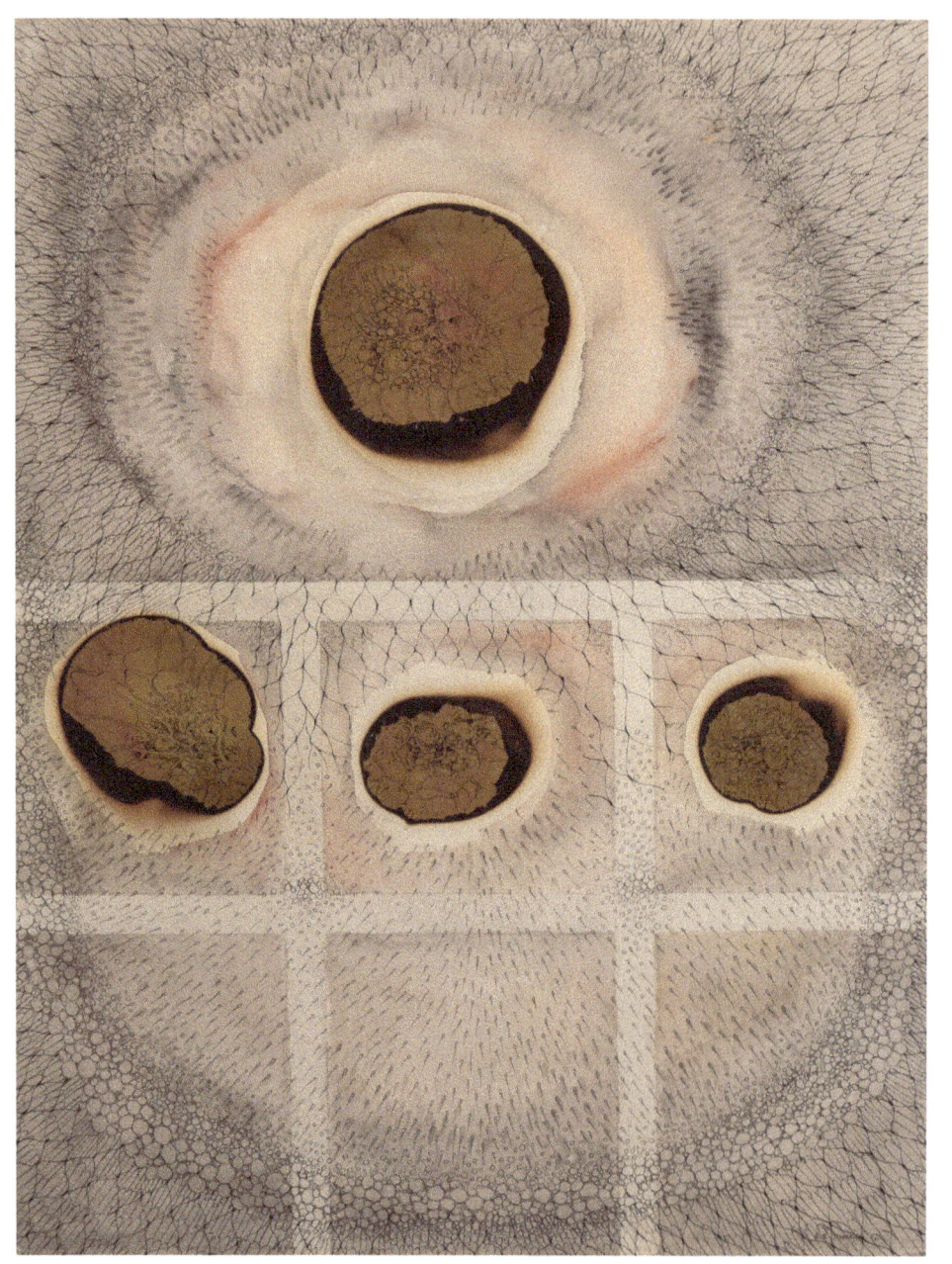

Jeanet DRESKIN | MFA 1973
Sere XIII
Watercolor, ink, collage

Terry JARRARD-DIMOND | MFA 1979
Abundance
Acrylic paint on paper

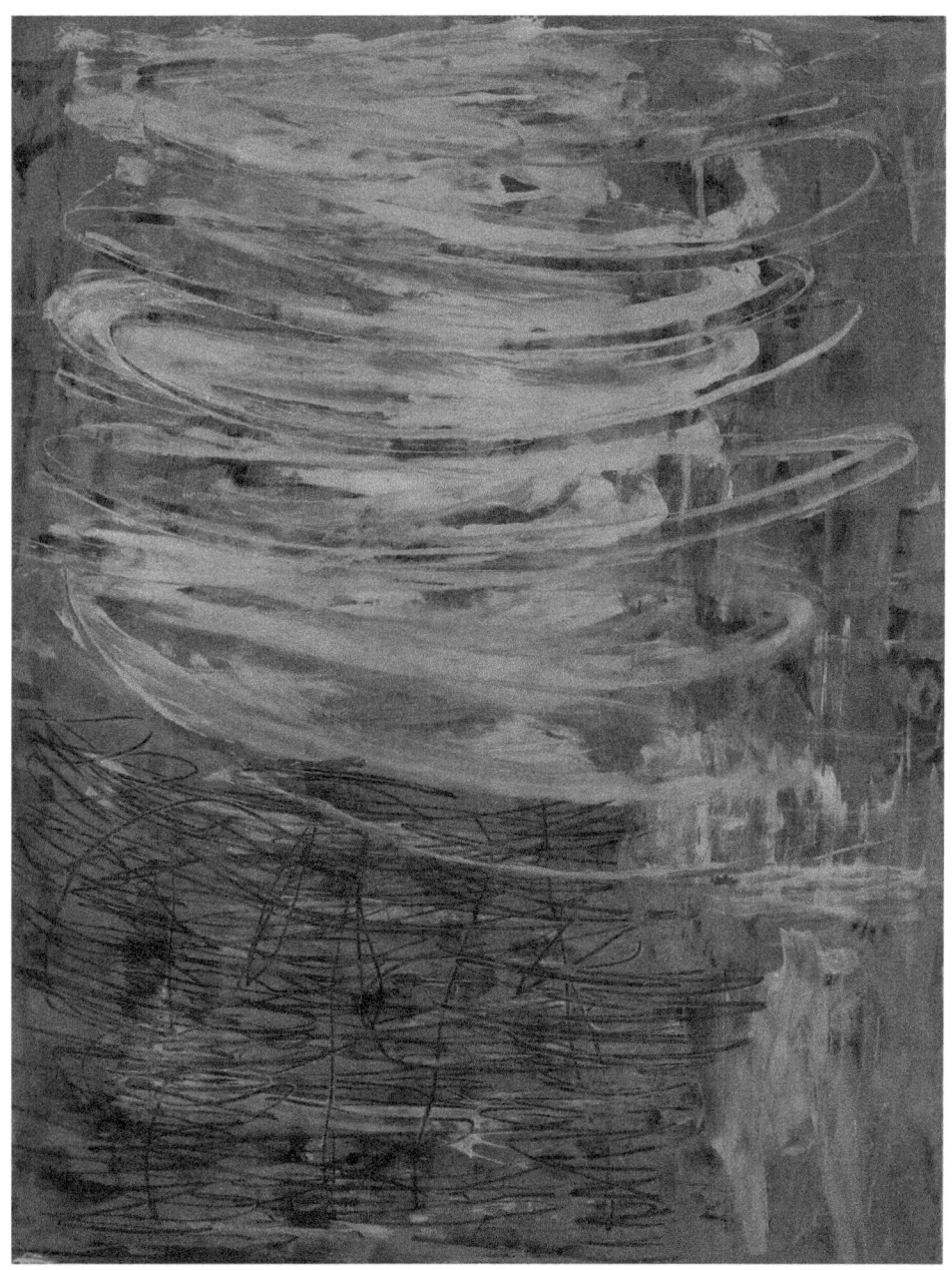

Susan WOOTEN | MFA 1977
CHAOS: Still Weeping
Graphite pencil on paper

1980s

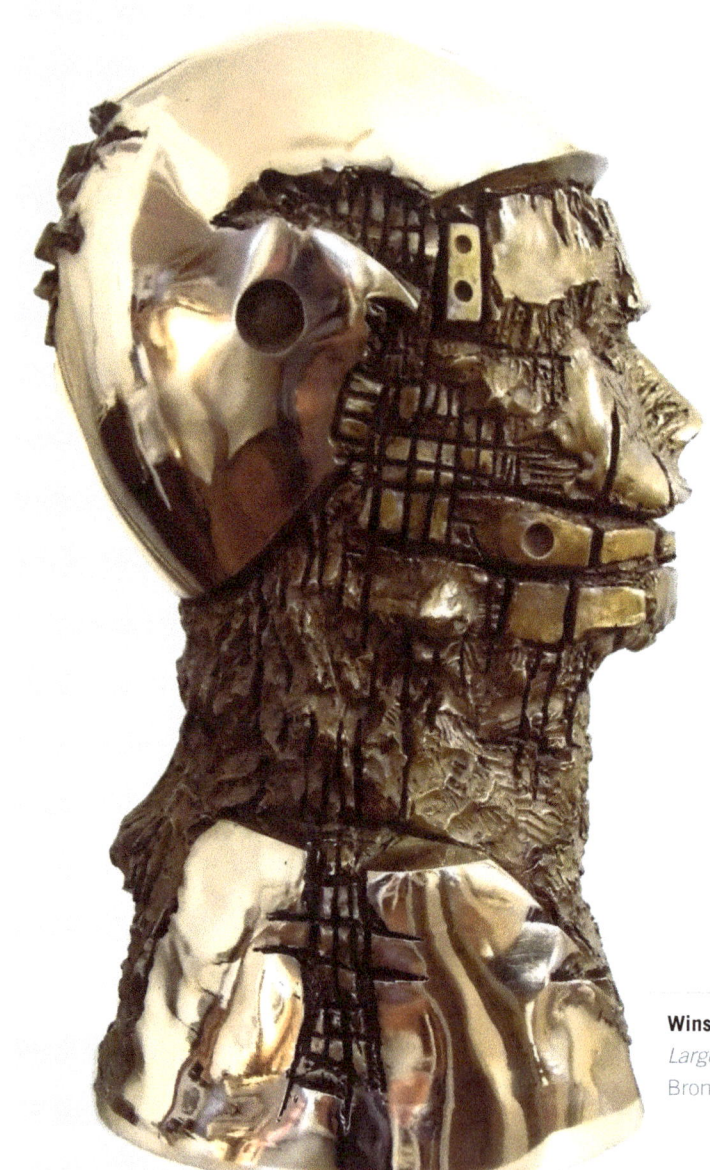

Winston WINGO | MFA 1980
Large Techno Head
Bronze

Jerry GORMAN | MFA 1983
Moonlight Snow Over Italy
Acrylic on canvas

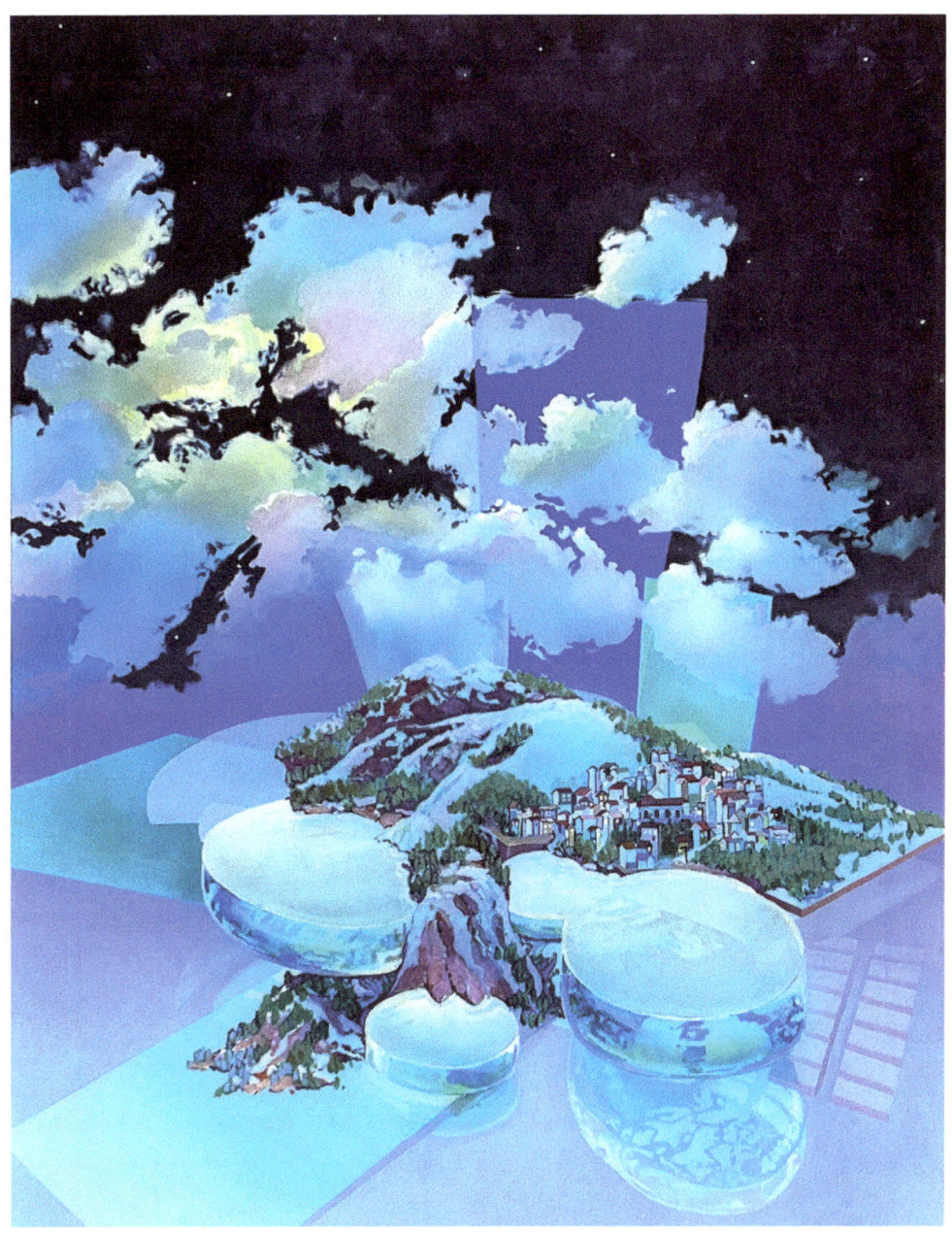

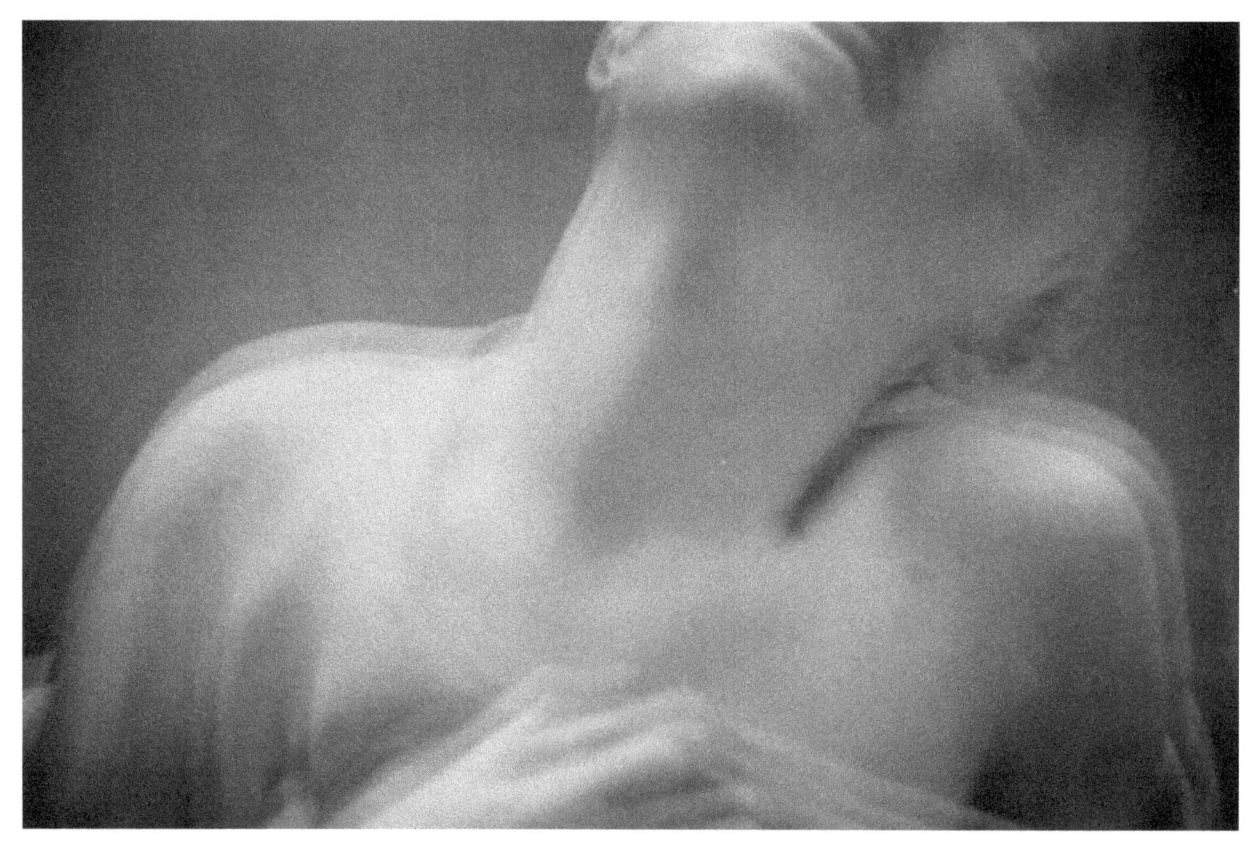

Gilbert LEEBRICK | MFA 1989
Russia
Handcrafted archival silver gelatin print

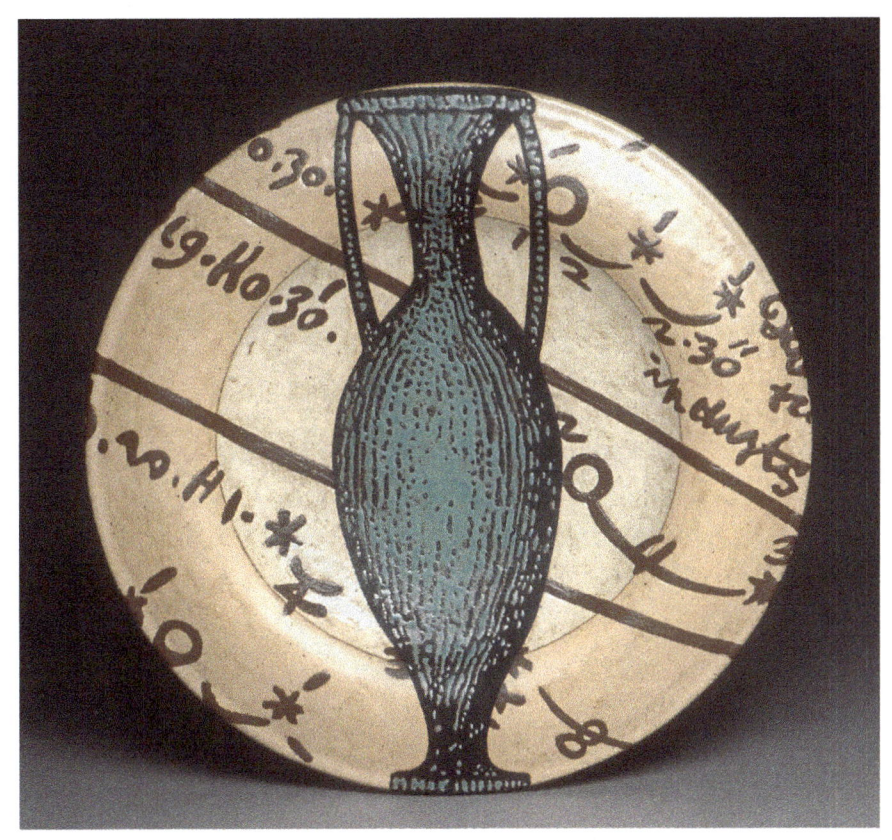

Jeanée REDMOND | MFA 1981
Galileo
Ceramic plate

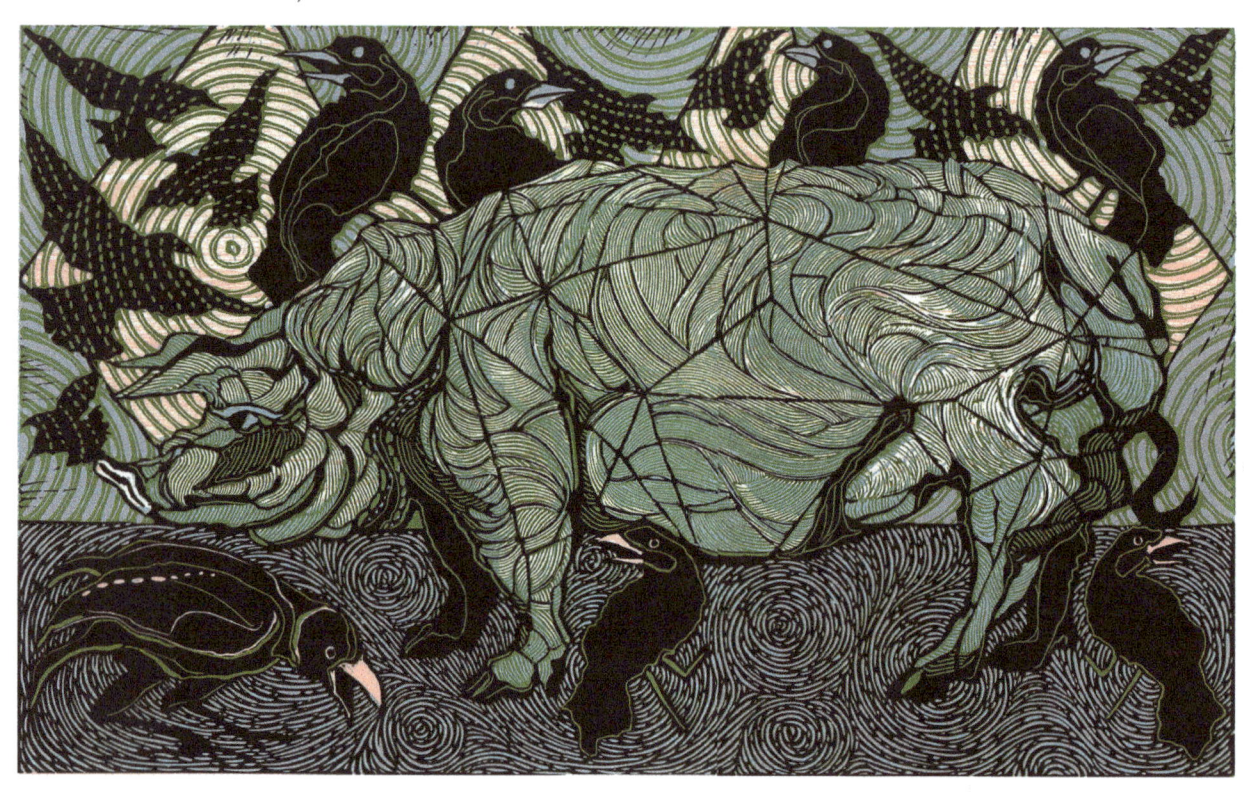

Dale CLIFFORD | MFA 1989
War Machine
Linocut and woodcut

Cecile MARTIN | MFA 1989
Looking for Grandmother
Graphite

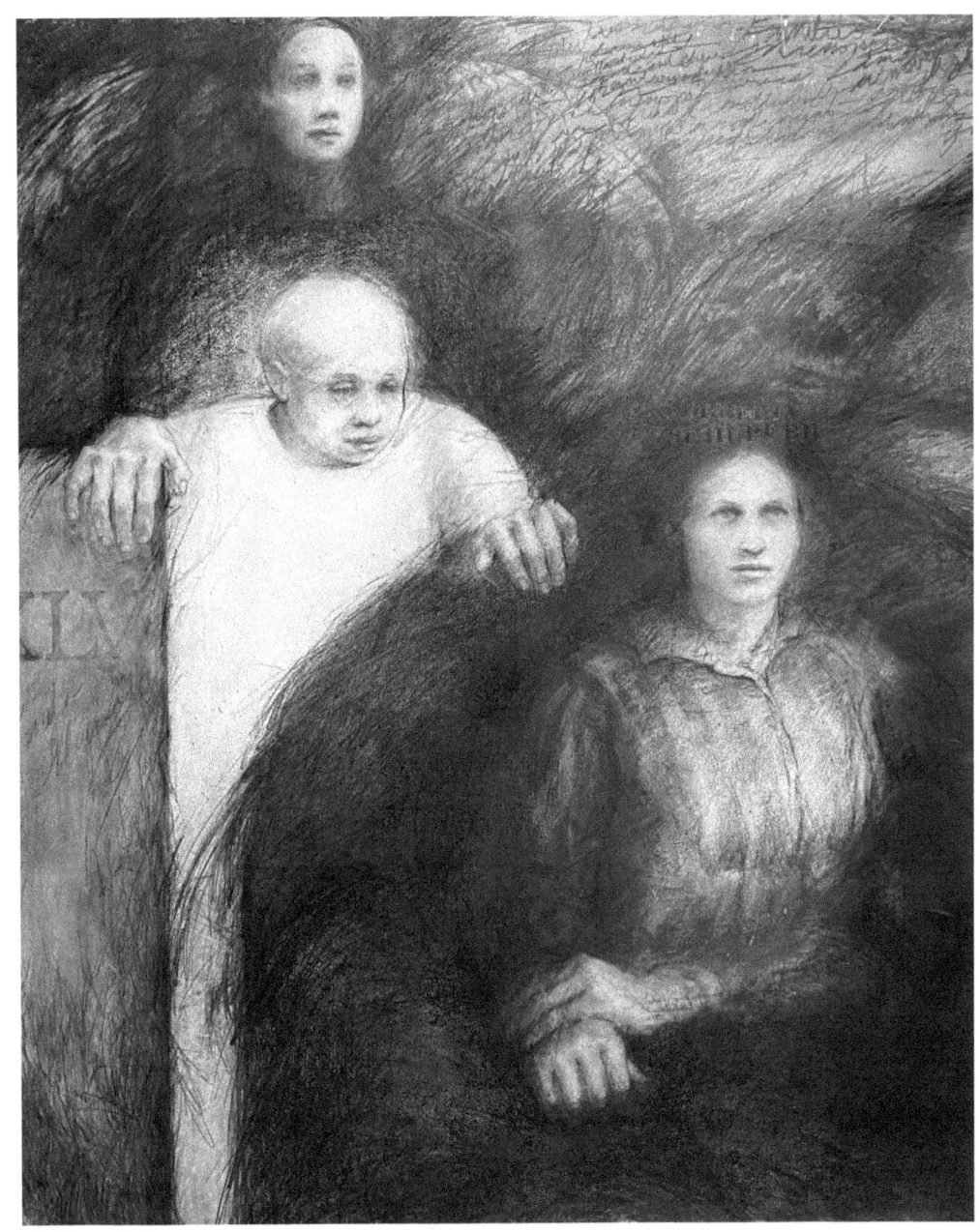

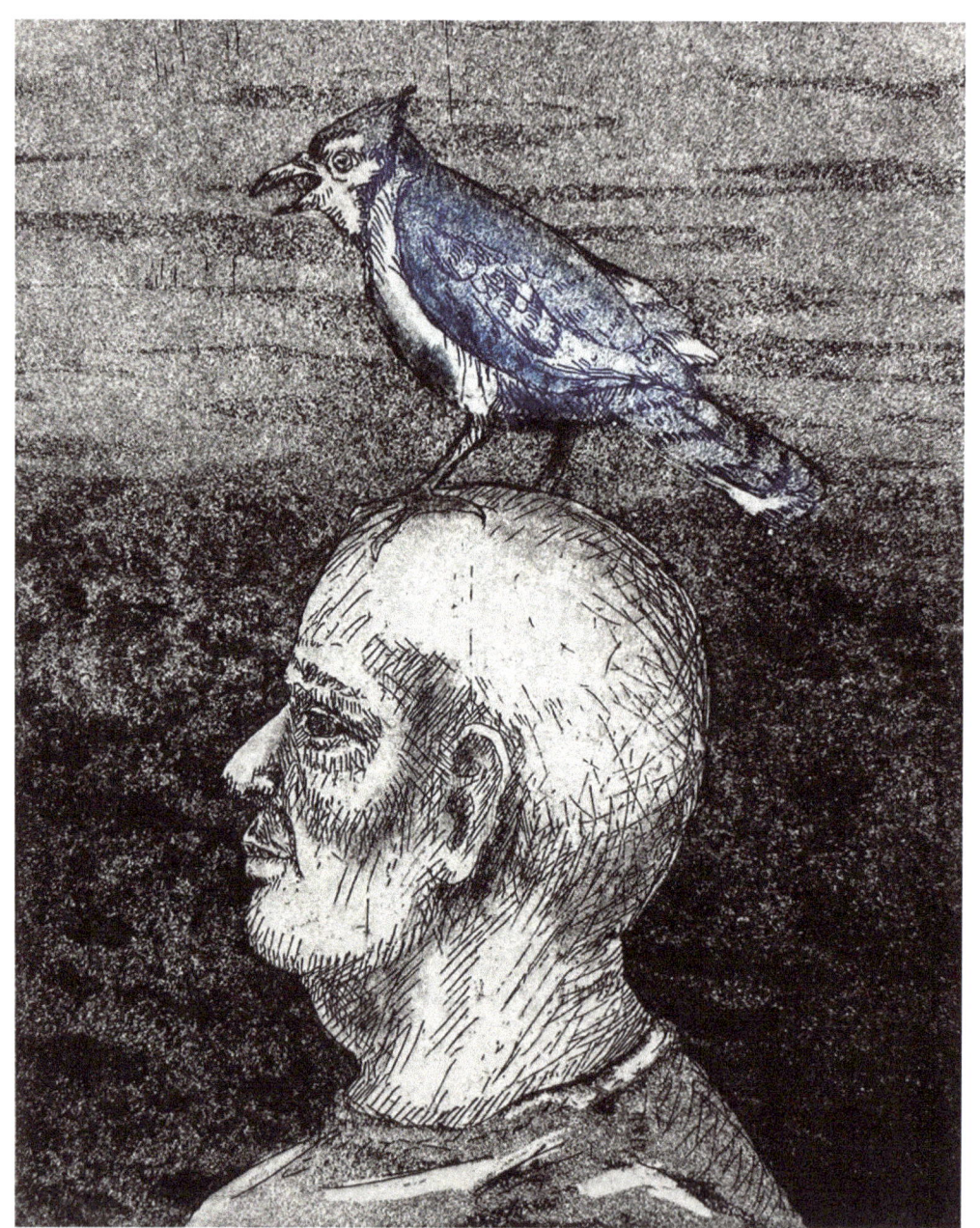

Steven CHAPP | MFA 1985
Jay-II
Etching and aquatint on zinc

Jo Carol MITCHELL-ROGERS | MFA 1986
These Numbered Days
Acrylic and graphite

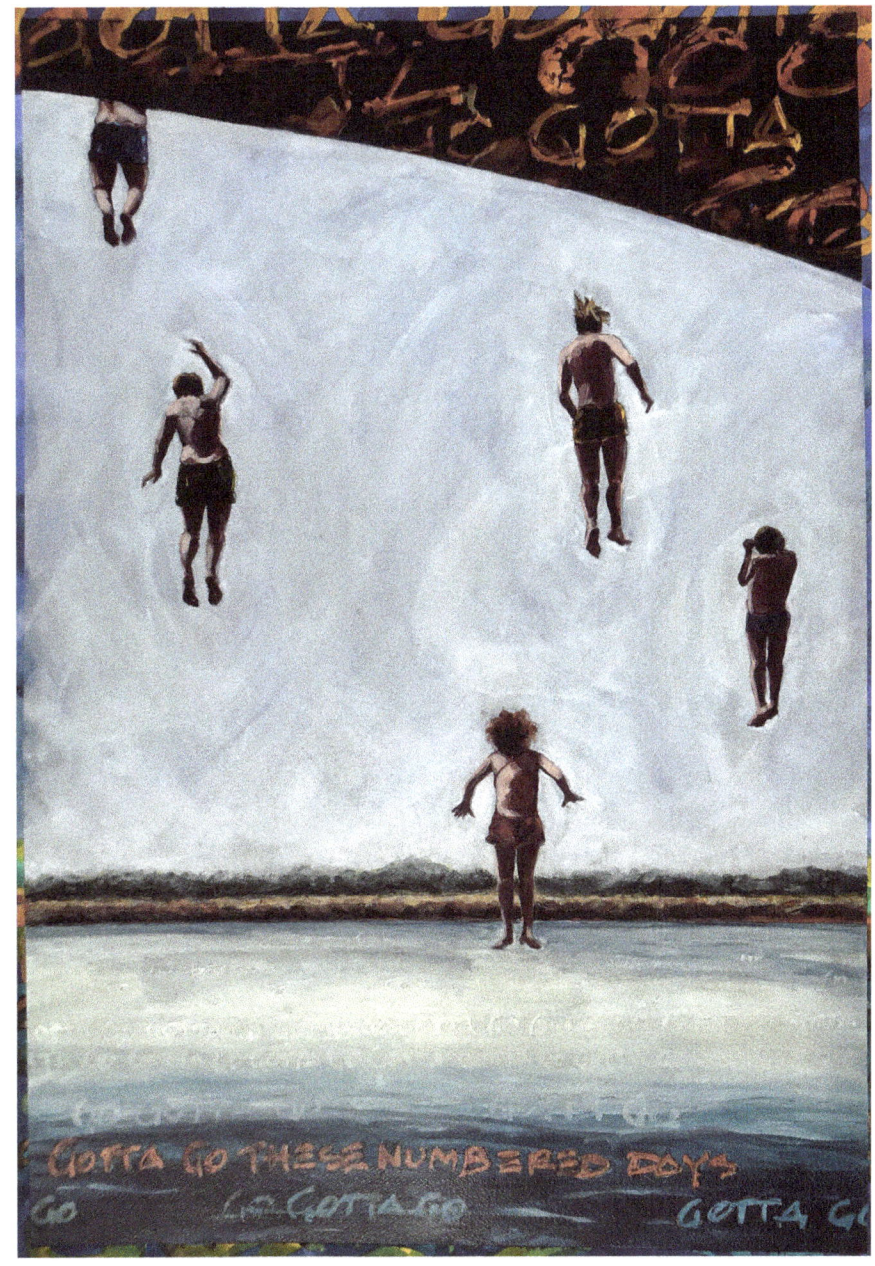

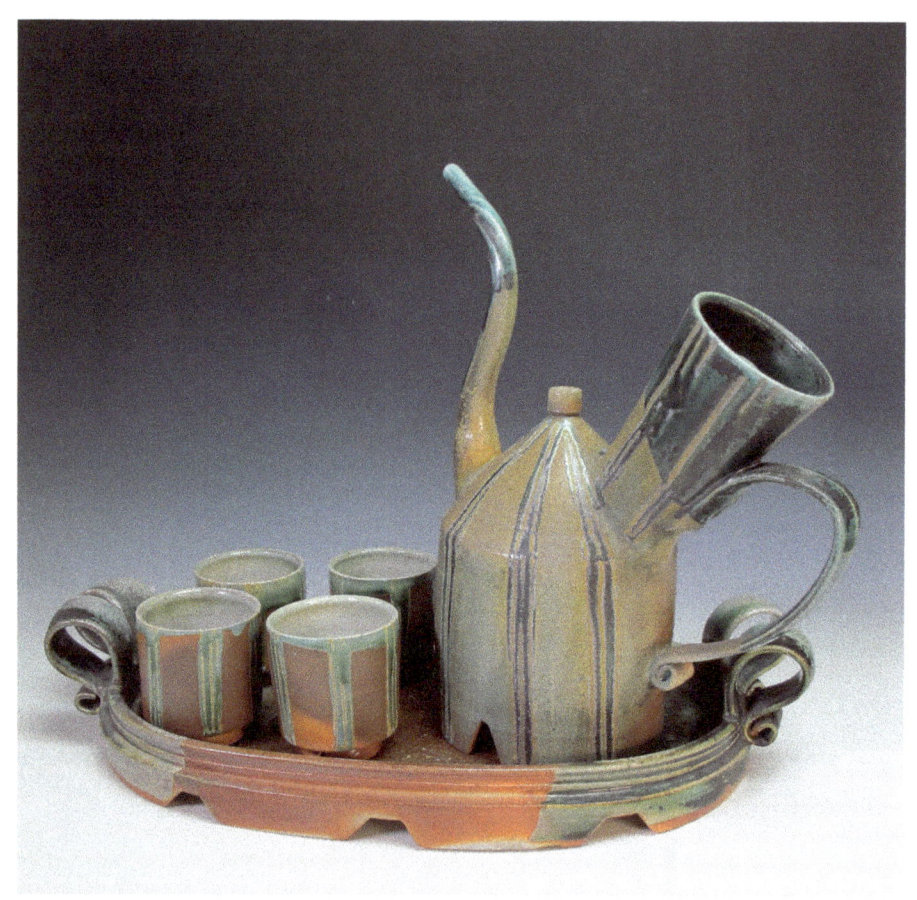

Alan WILLOUGHBY | MFA 1983
Ewer with Tumblers and Tray
Wood fired white stoneware clay, wheel thrown & handbuilt

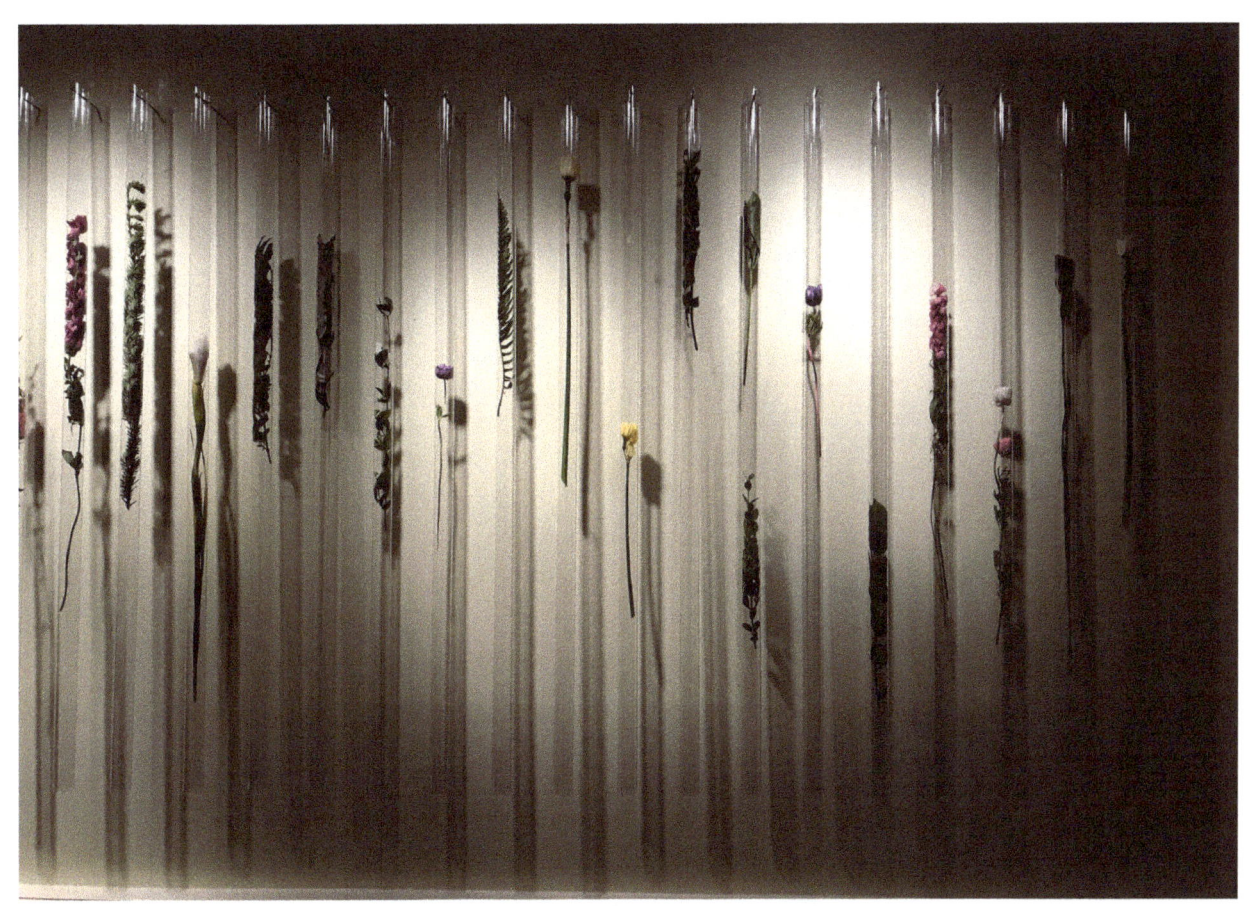

Richard LOU | MFA 1986
Wild Stasis
Plastic tubes, strips of digital photographs, preserved plants, nails

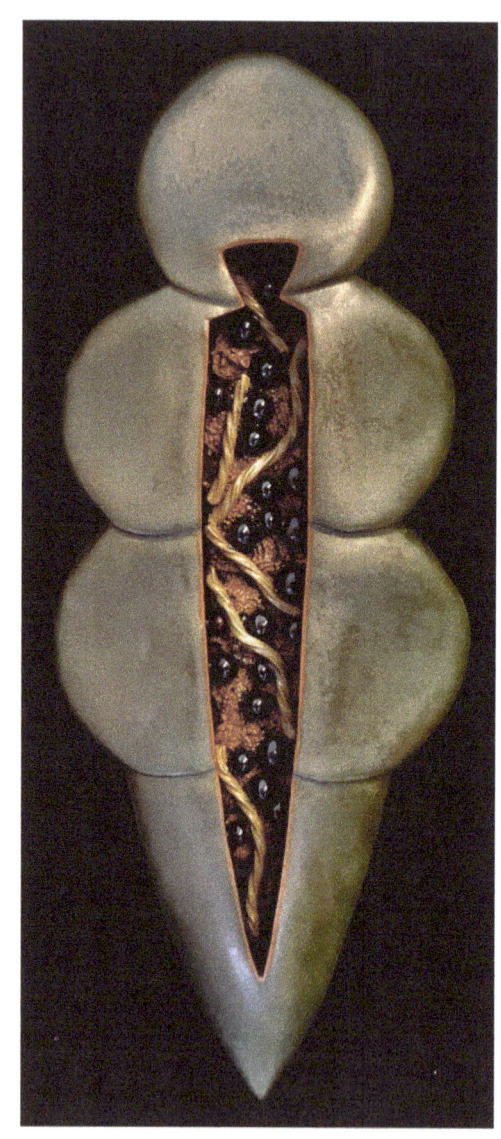

Glenda GUION | MFA 1985
Pod Mandorla
Red earthenware clay and glaze

1990s

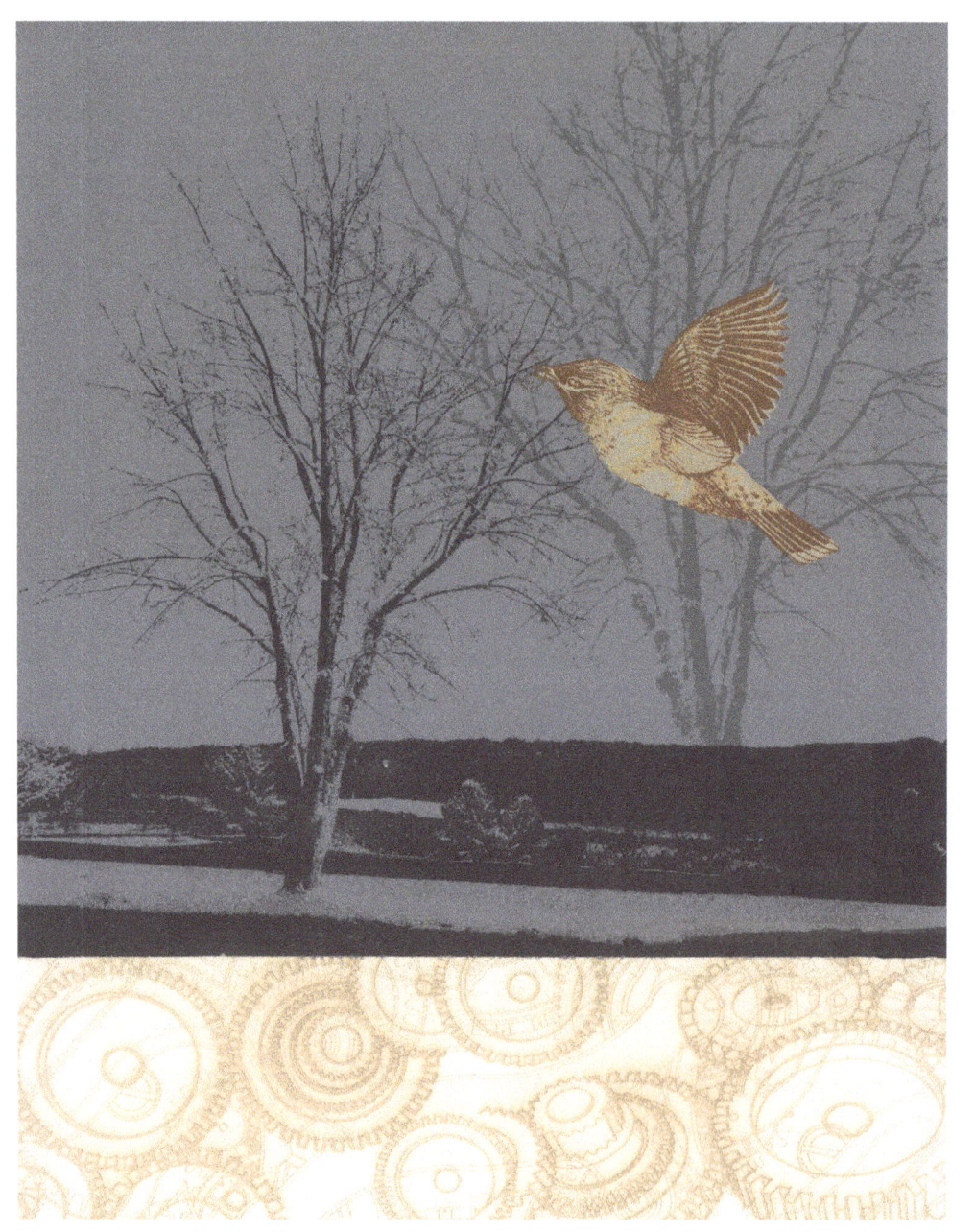

Maggie DENK-LEIGH | MFA 199
Nesting
Screenprint and laser etched
Rives BFK paper

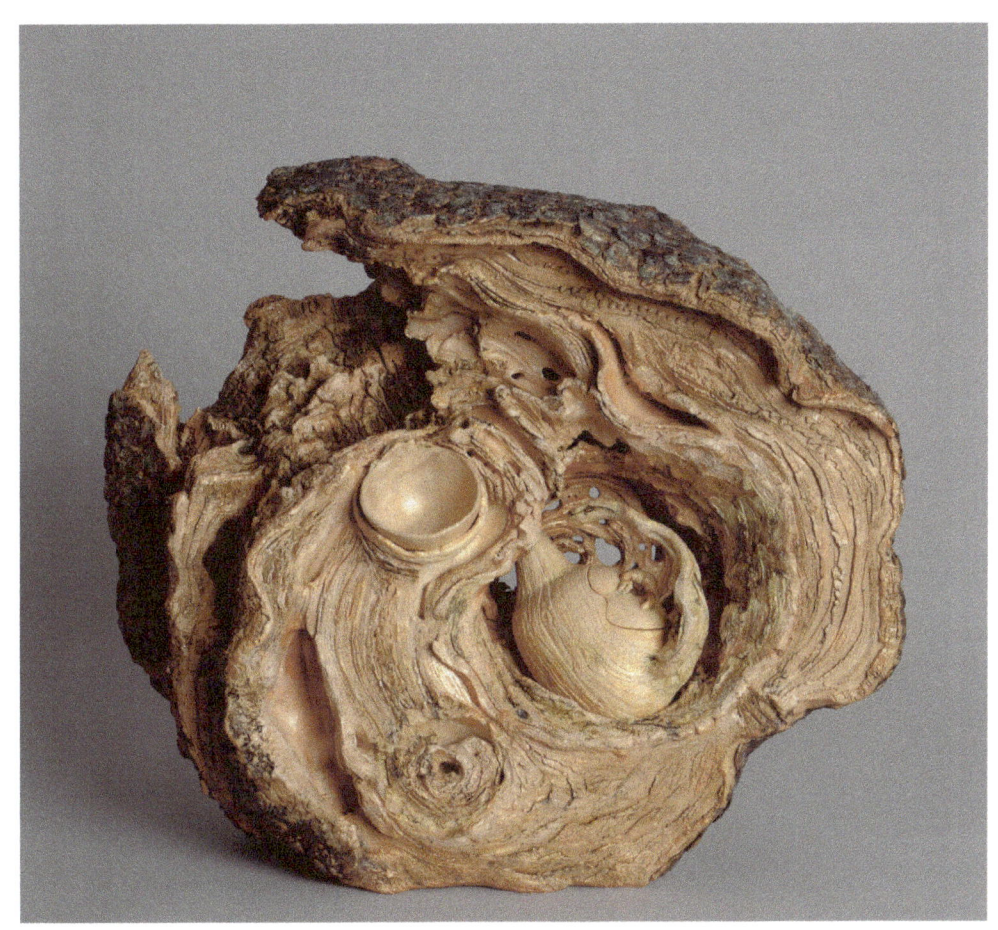

Elizabeth KELLER | MFA 1992
Heartwood Tea Set
Mixed stoneware, metallic oxide washes, enamels

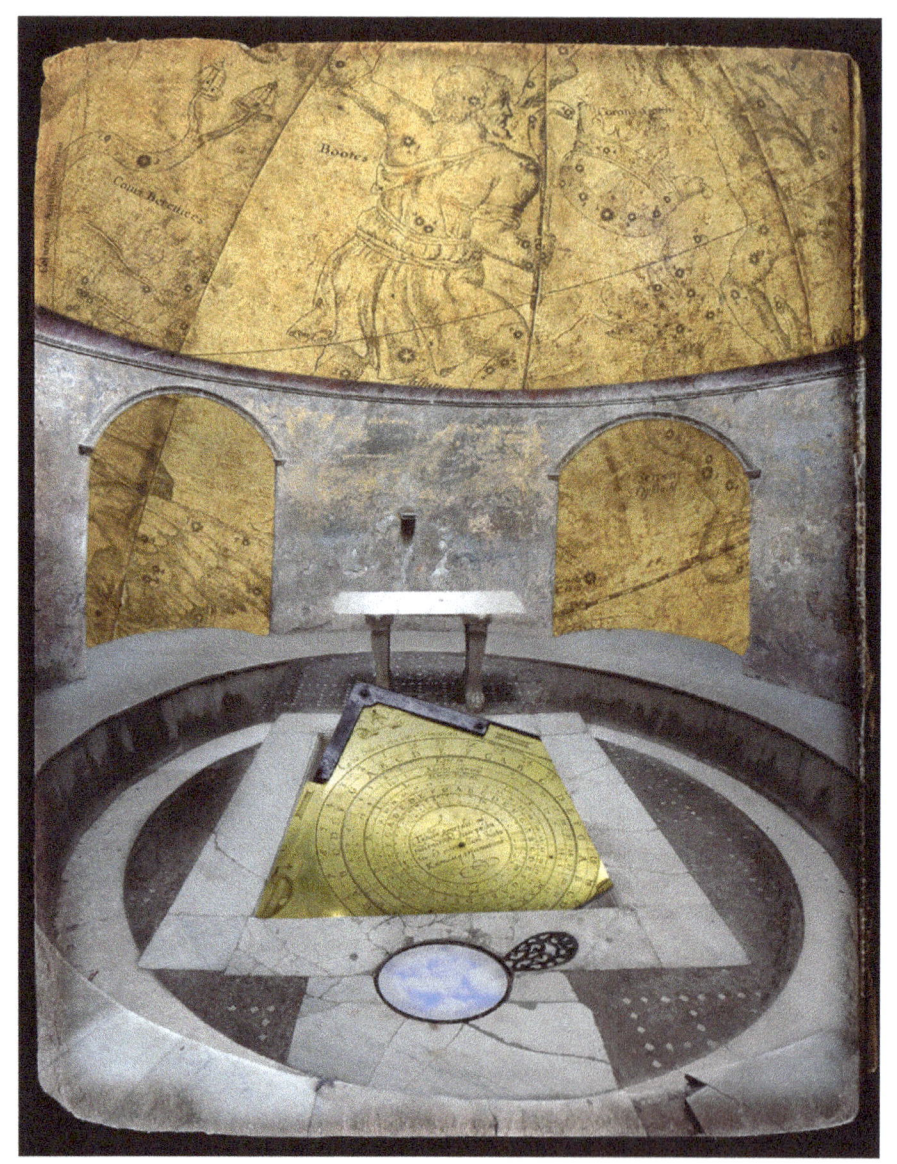

Jacquelyn LEEBRICK | MFA 19
Ptolemy's Cosmology
Digital collage transfer
on cradled birch board

Fleming MARKEL | MFA 1998
Tuesday Afternoon
Mixed media

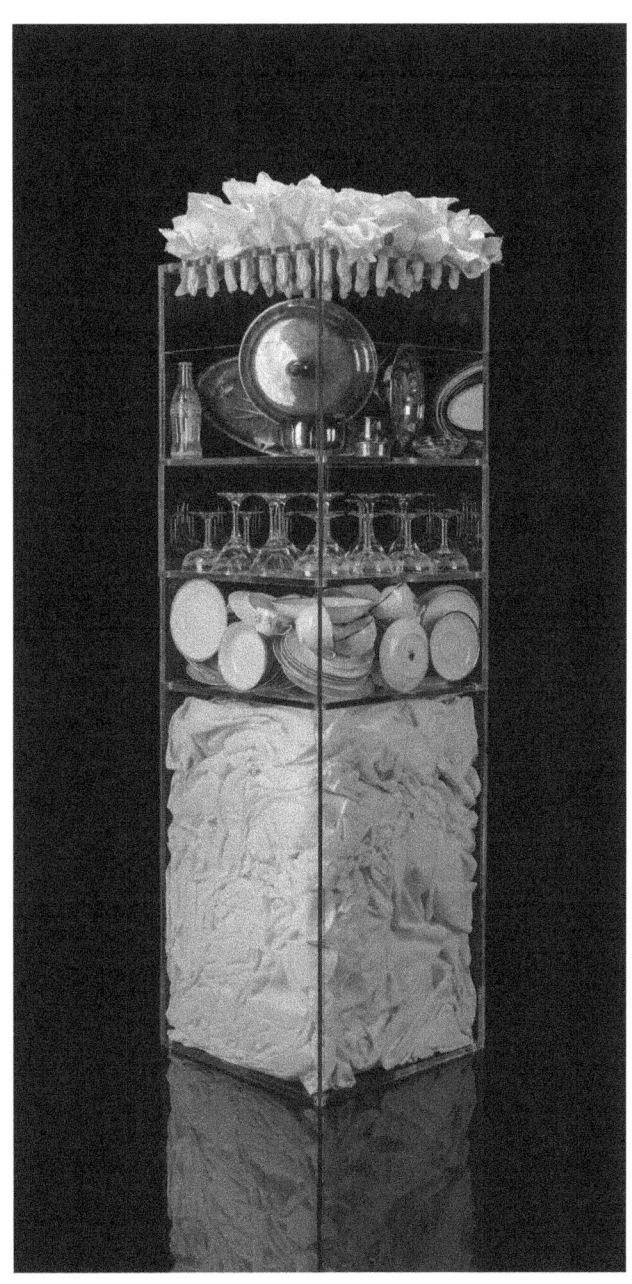

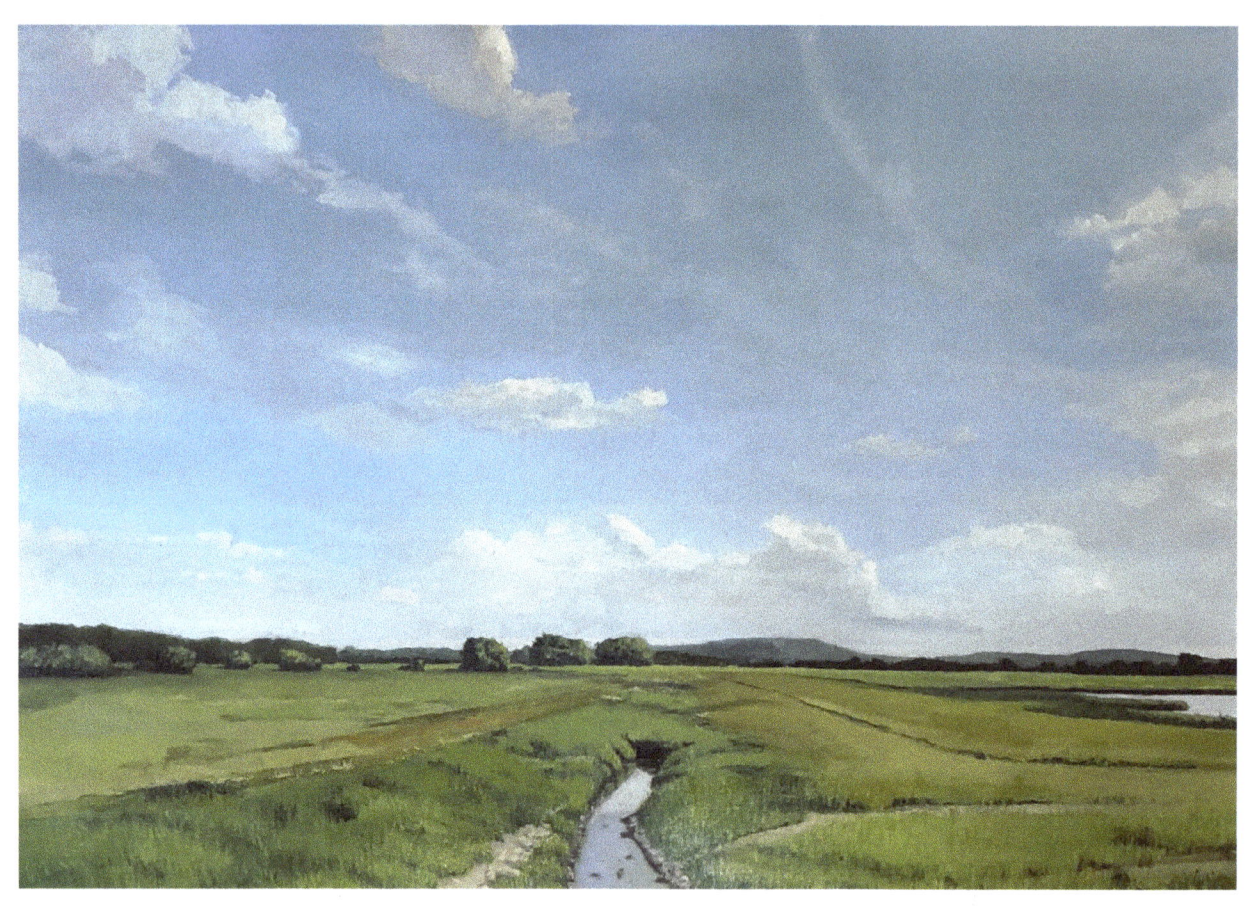

Ross HORTON | MFA 1993
Wakarusa Drainage Canal
Oil on paper

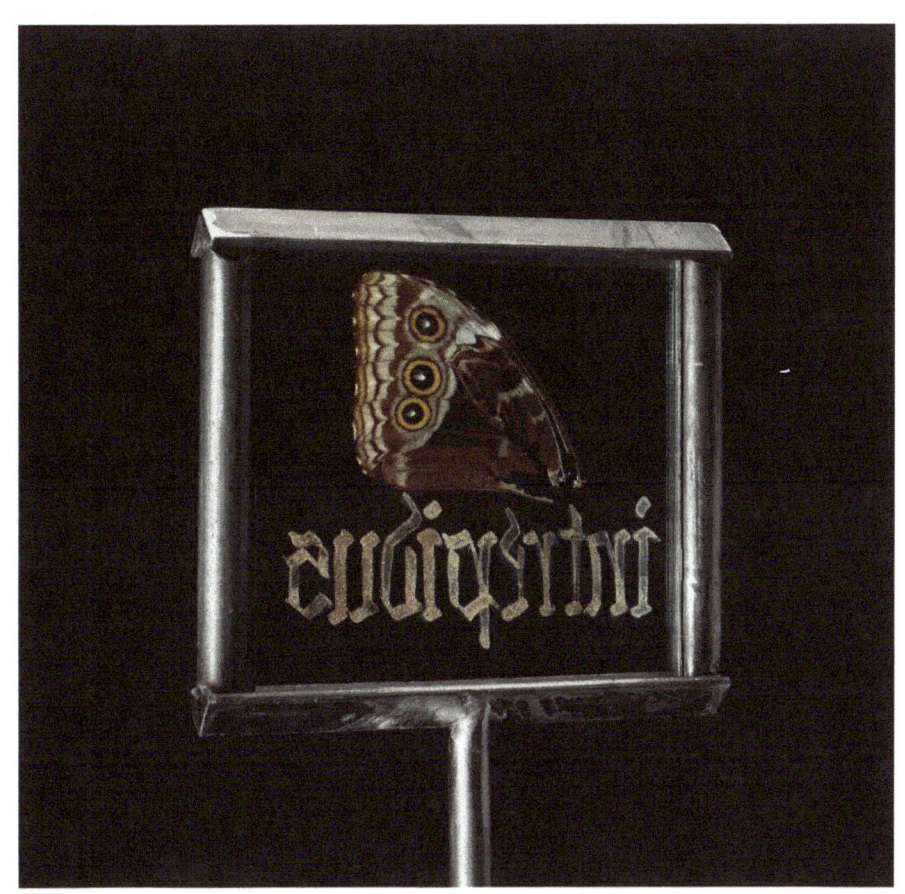

Shane HOWELL | MFA 1997
Pursuit
Steel, specimen slides, gold ink, gold-leafed butterfly scales, Blue Morpho butterfly wing

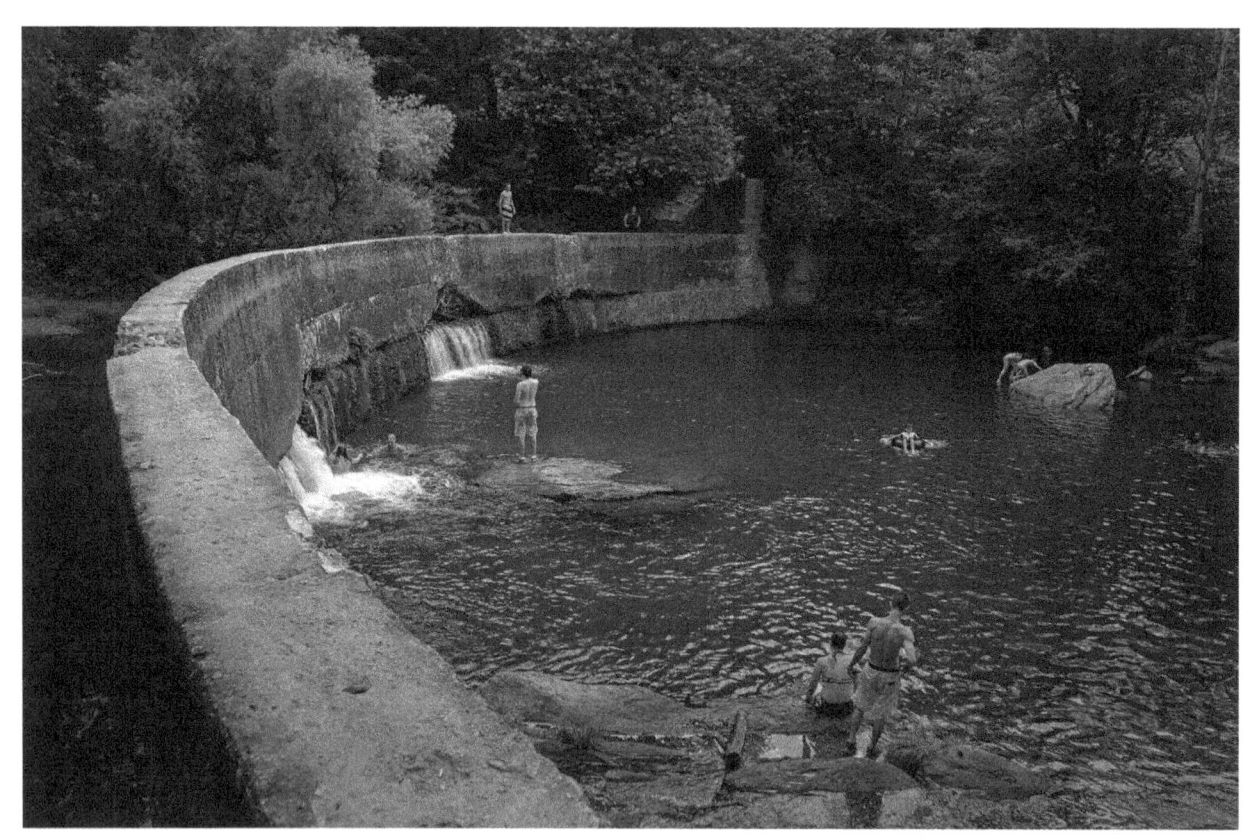

W. Cameron DENNIS | MFA 1990
Swimmers at the Dam
Inkjet print

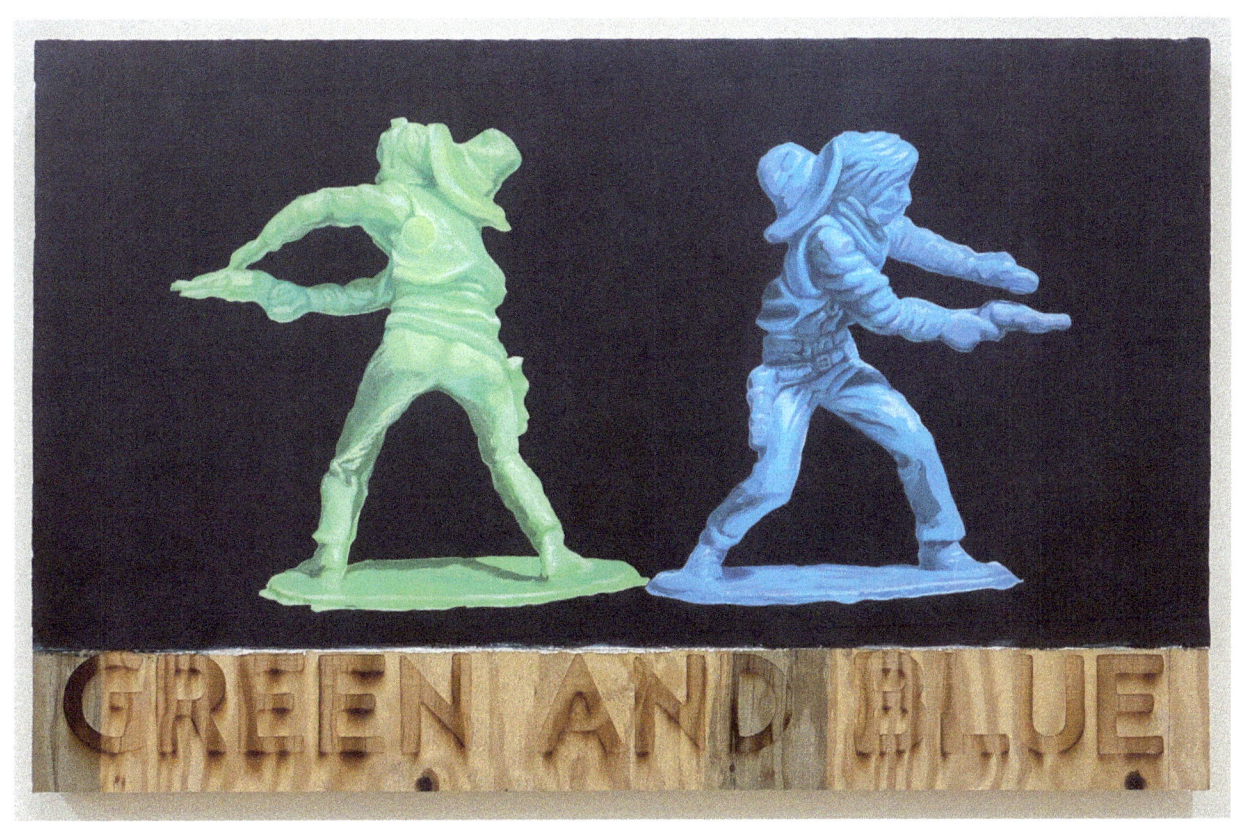

John WOLFER | MFA 1998
The Dualists
Acrylic paint and laser-etched text on plywood

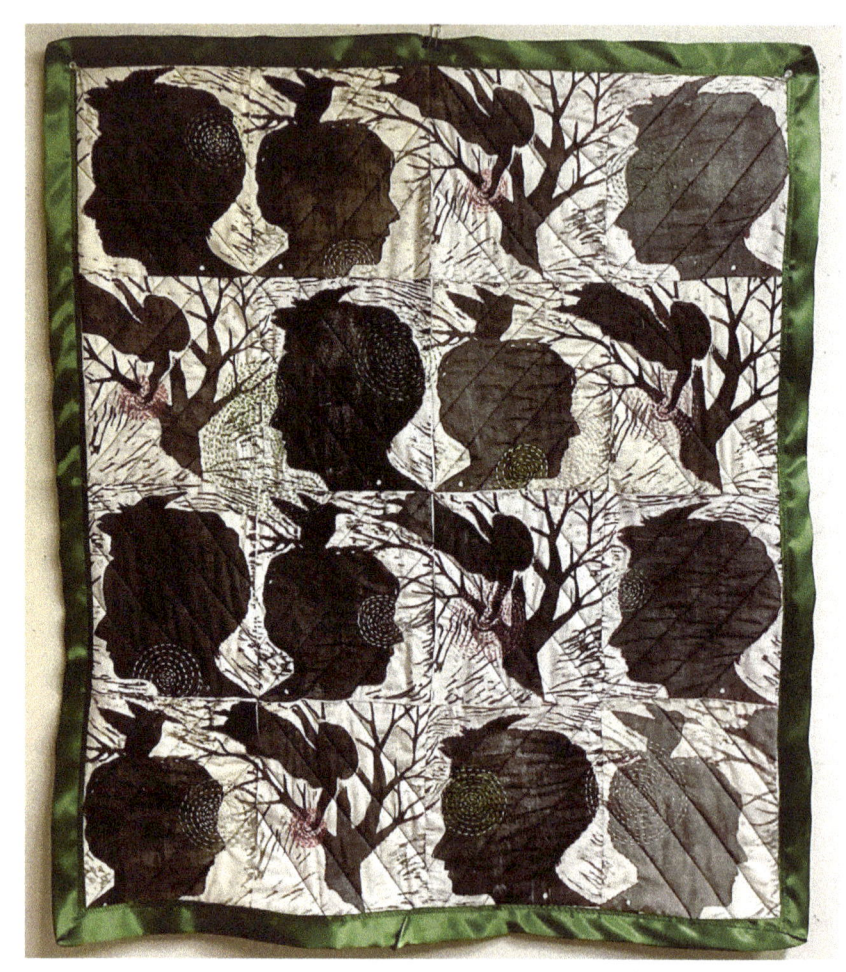

Terri DOWELL-DENNIS | MFA 1990
Spring
Woodcut on muslin, embroidery, stitching

David TILLINGHAST | MFA 1994
Conversion
Oil on canvas

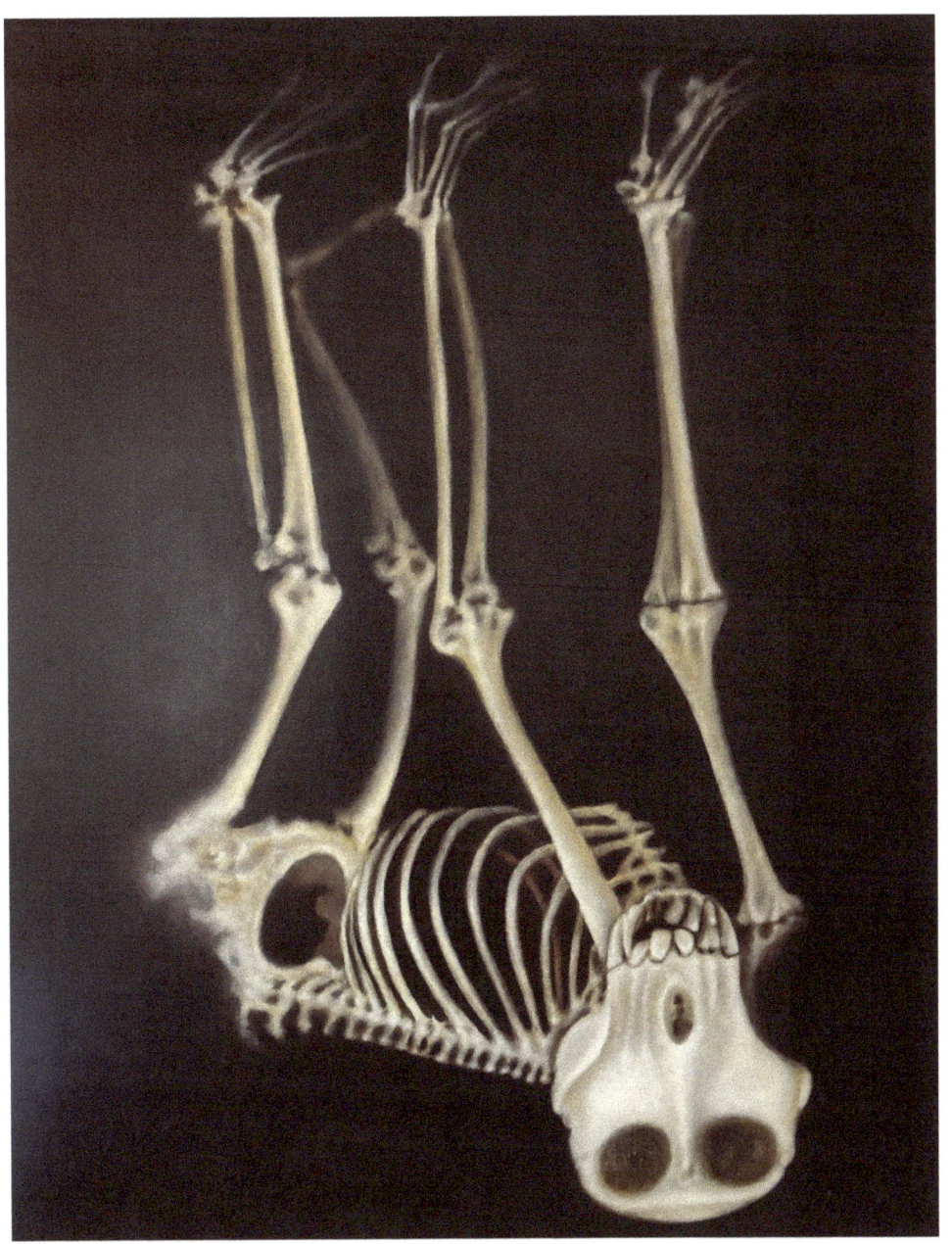

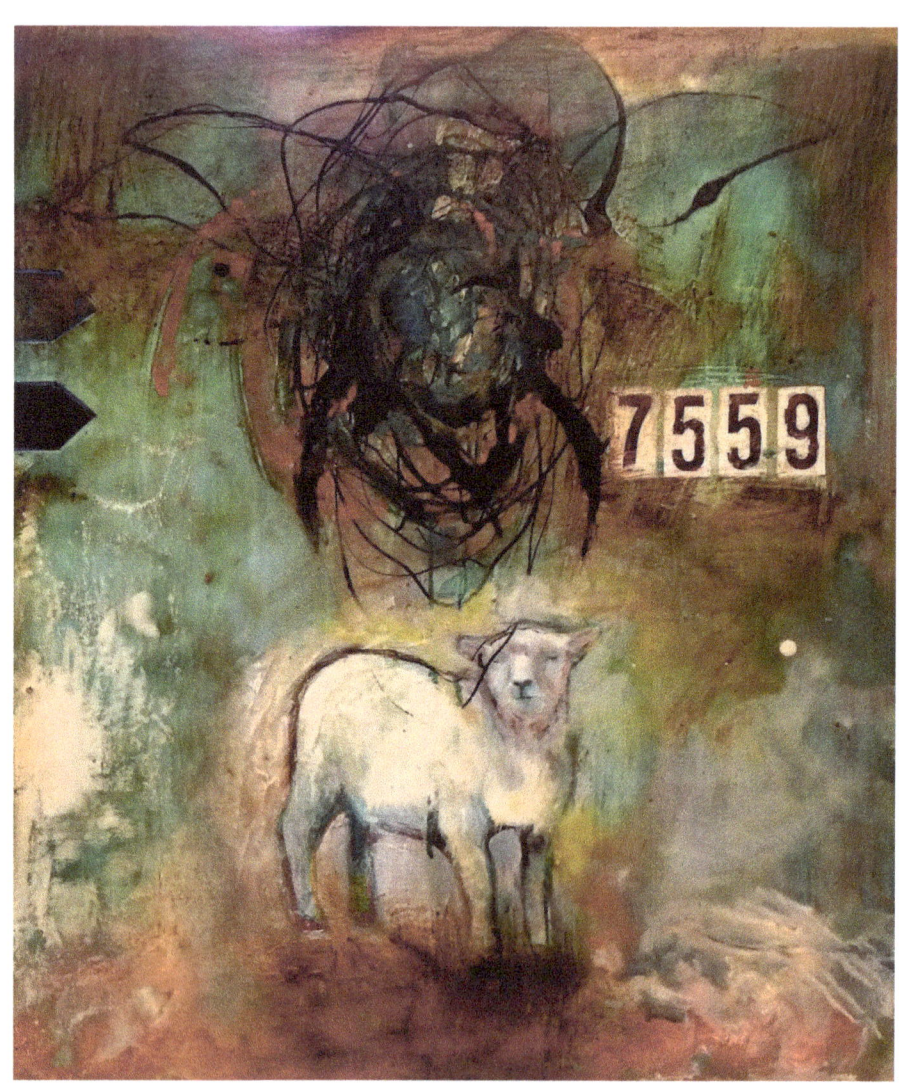

Kristen WOODWARD | MFA 199
7559
Encaustic on cradled wood par

Blake PRAYTOR | MFA 1998
Pawleys Island Daydream
from the series Passages
Pigment print

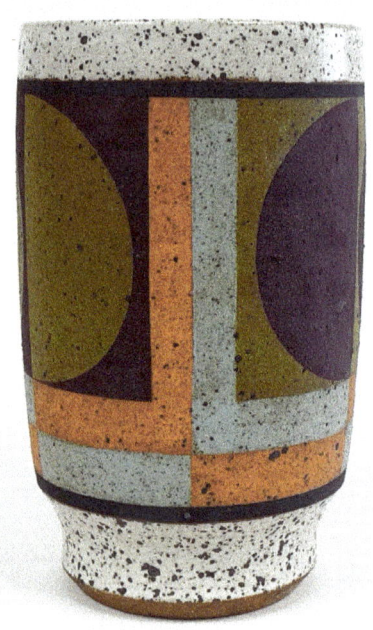

Kat HUTTER and Roger LEE | MFA 2006 and 2007
Large Vessel
Ceramic

2000s

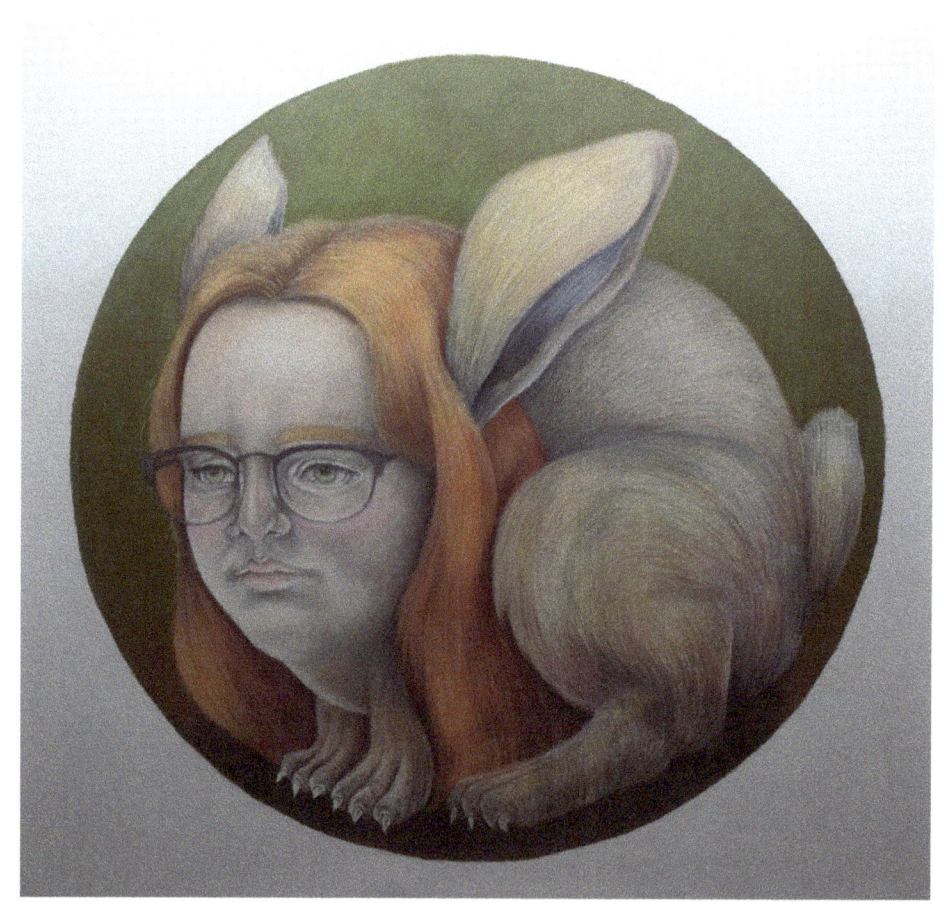

John HILTON | MFA 2002
Bella Bunny
Pastel on paper

Jennifer STONEKING-STEWART | MFA 2007
Heartfelt desires for what if (Sibyl)
Xerox toner, acrylic, matte medium, relief, collage, gesso, yarn

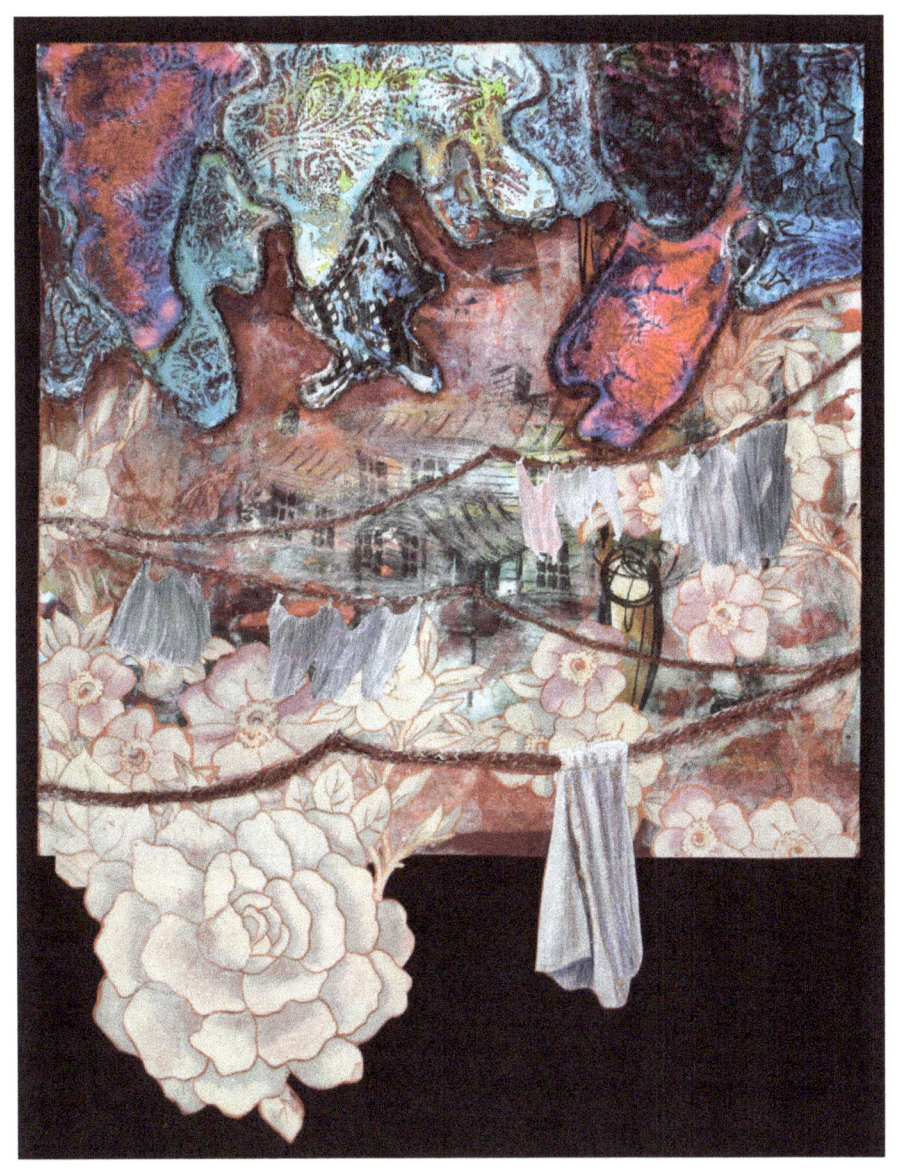

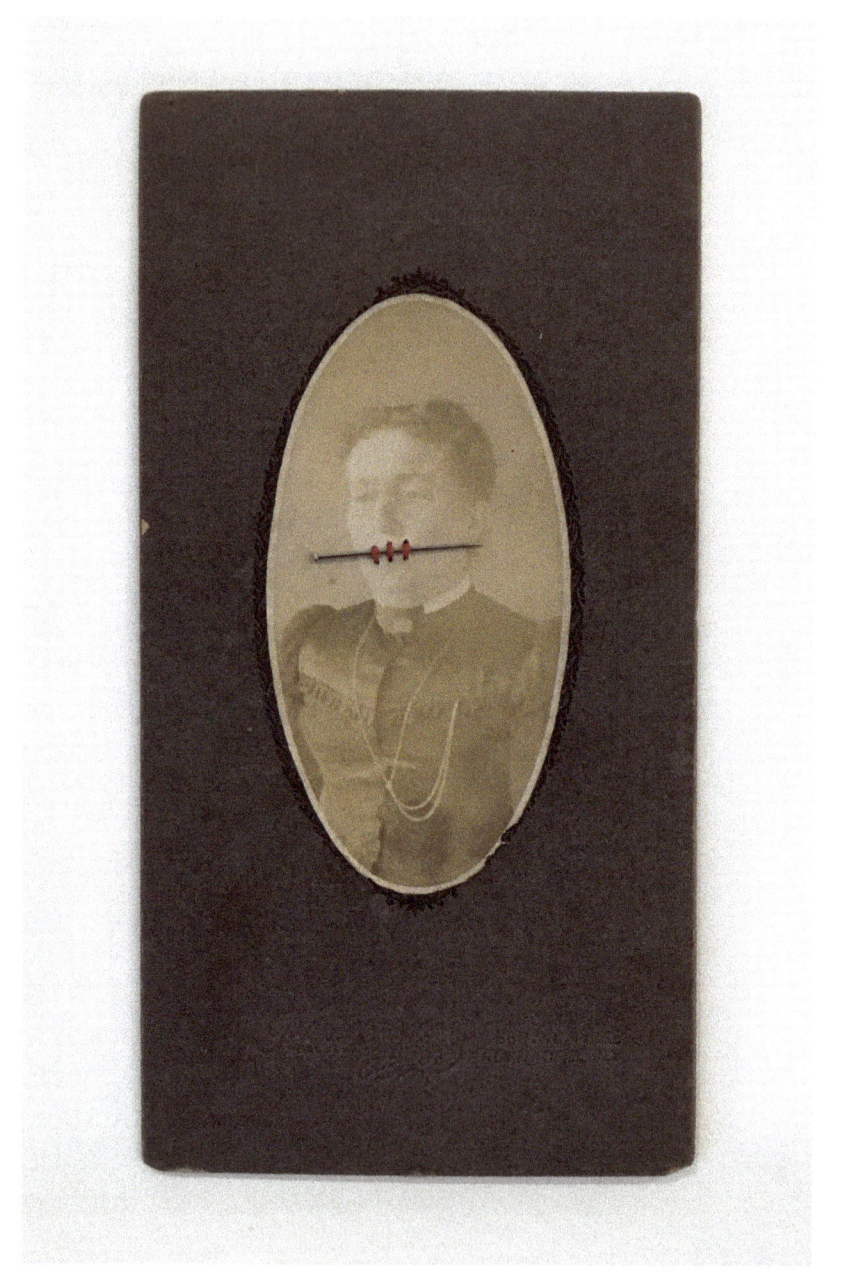

Blake SMITH | MFA 2002
Before the 19th Amendme
Mixed media

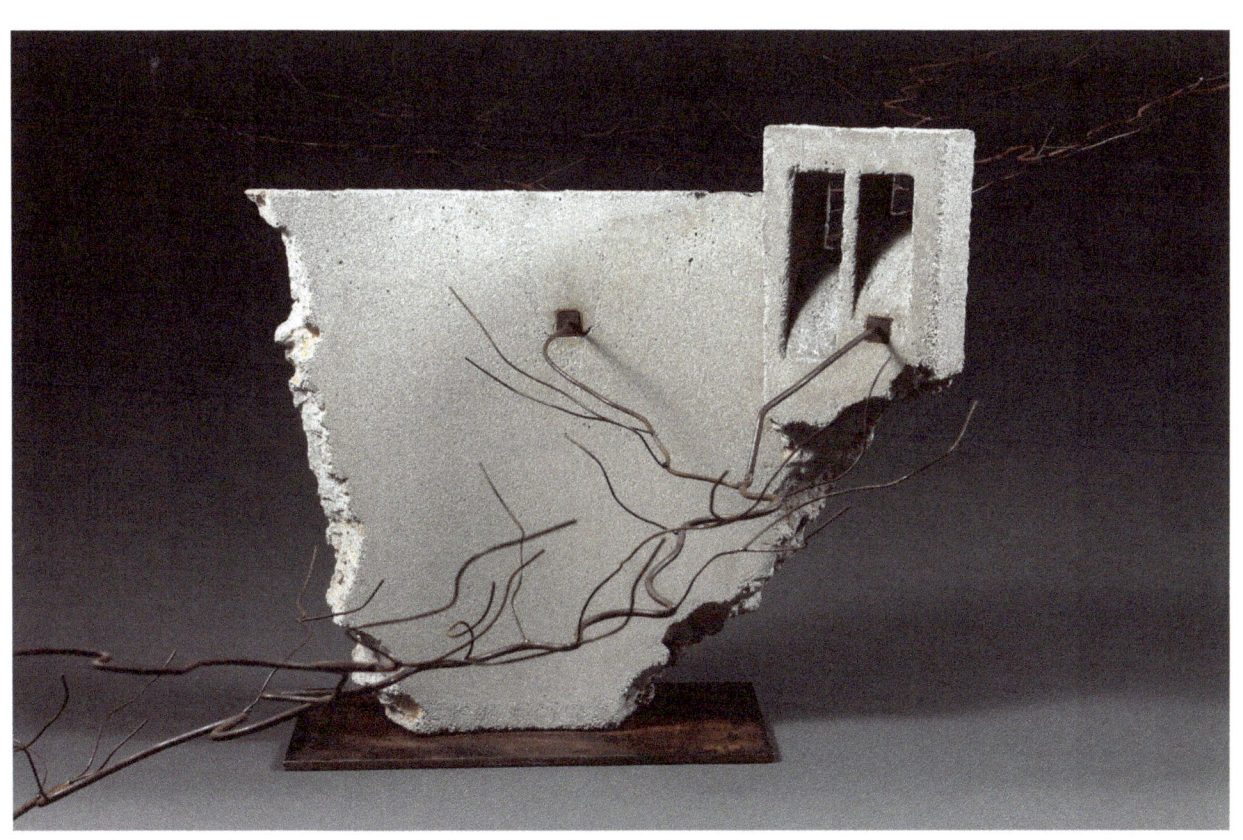

Matt WEST | MFA 2002
Green River/Tuxedo Dam
Concrete and steel

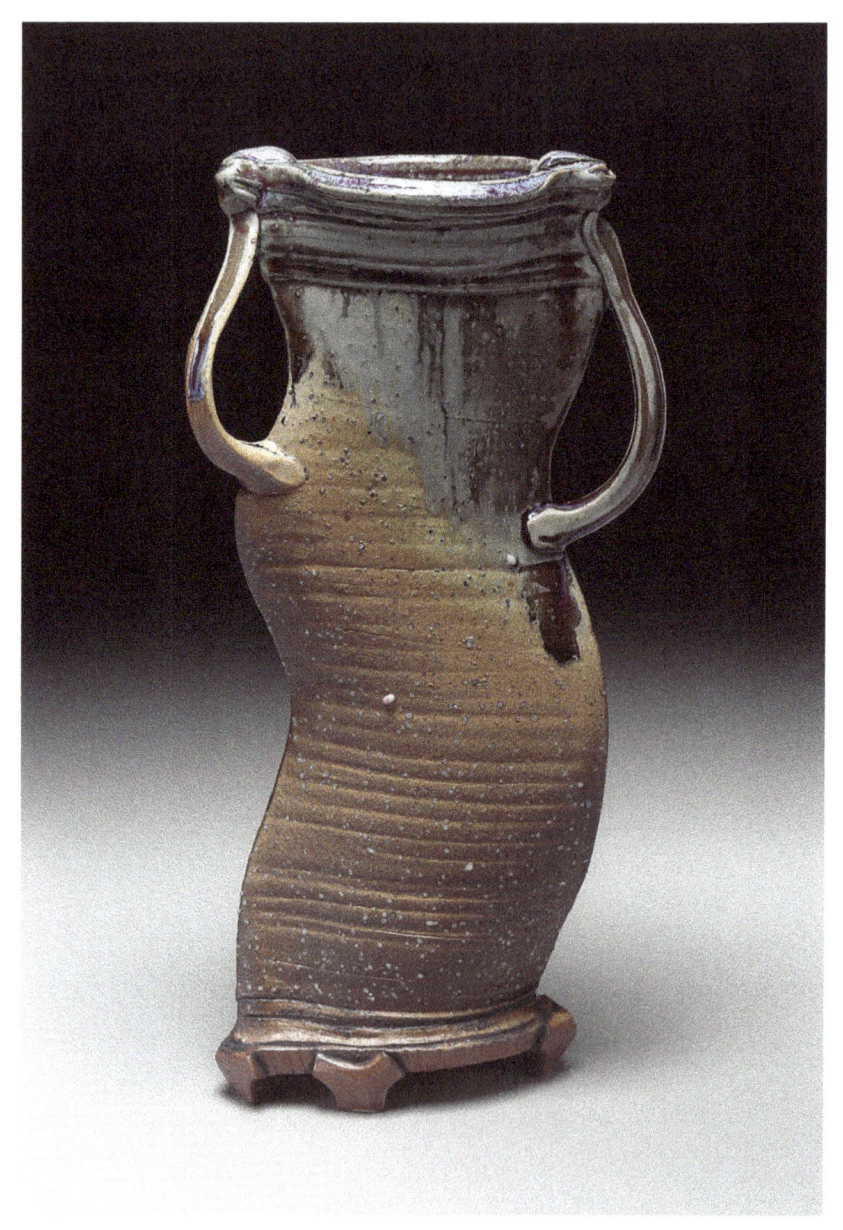

Sue GRIER | MFA 2004
Willow
Stoneware

Jenny HUTCHINSON | MFA 2009
Movements in Jade
Paper relief with assorted papers, colored pencil, acrylic paint, and paint marker

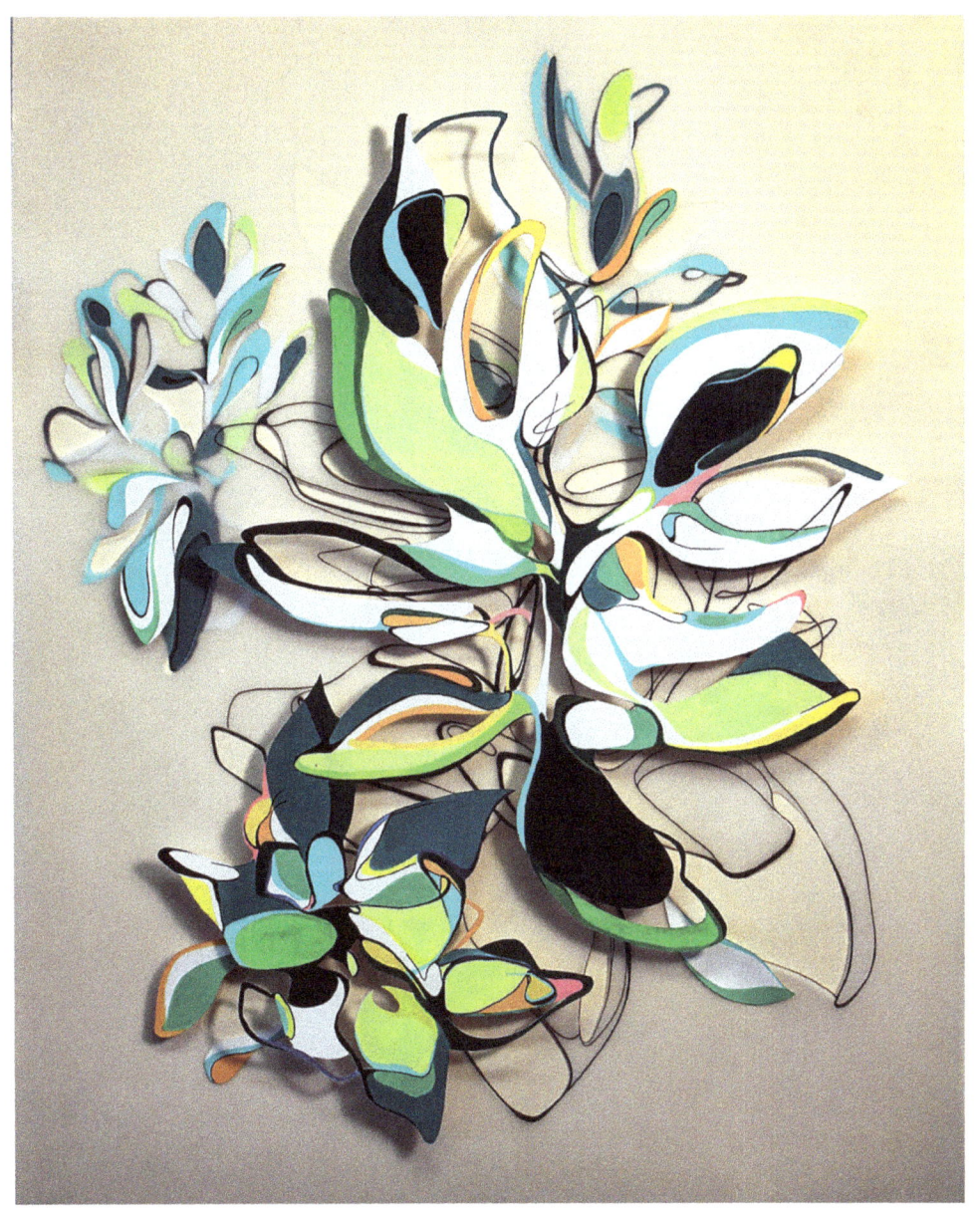

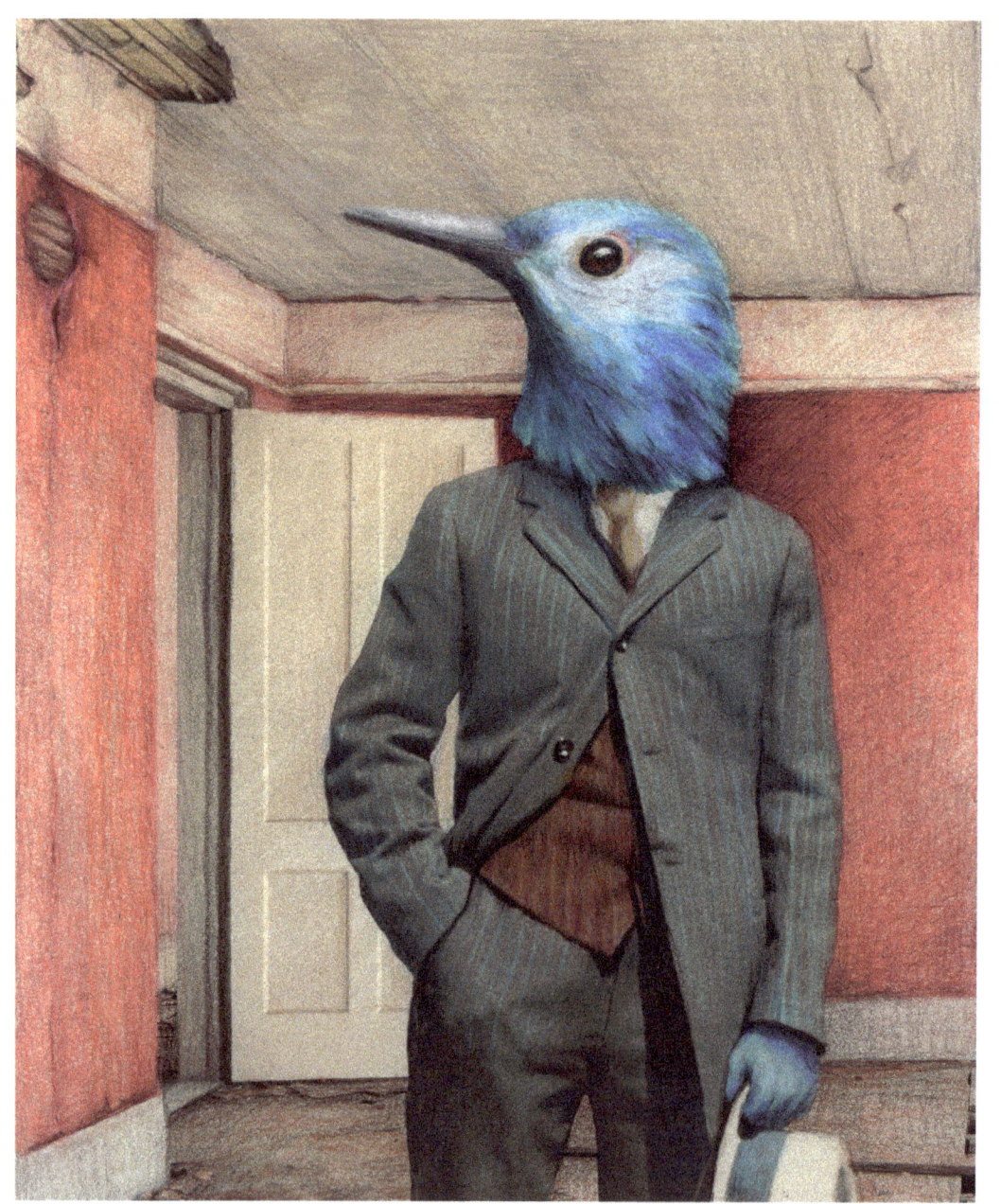

Paula SWISHER | MFA 20
At the Old House
Colored pencil and gouache
on digital print

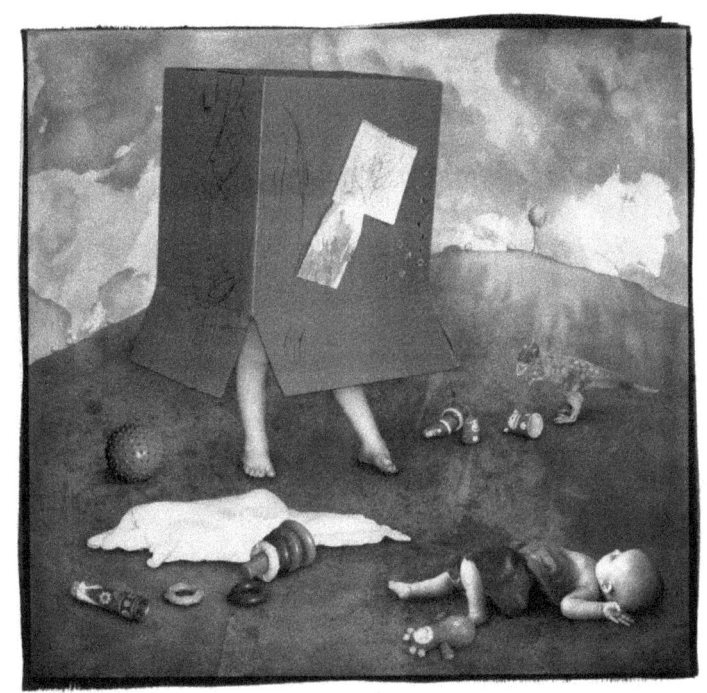

Amy Holmes GEORGE | MFA 2000
Not Just a Box
Ziatype print

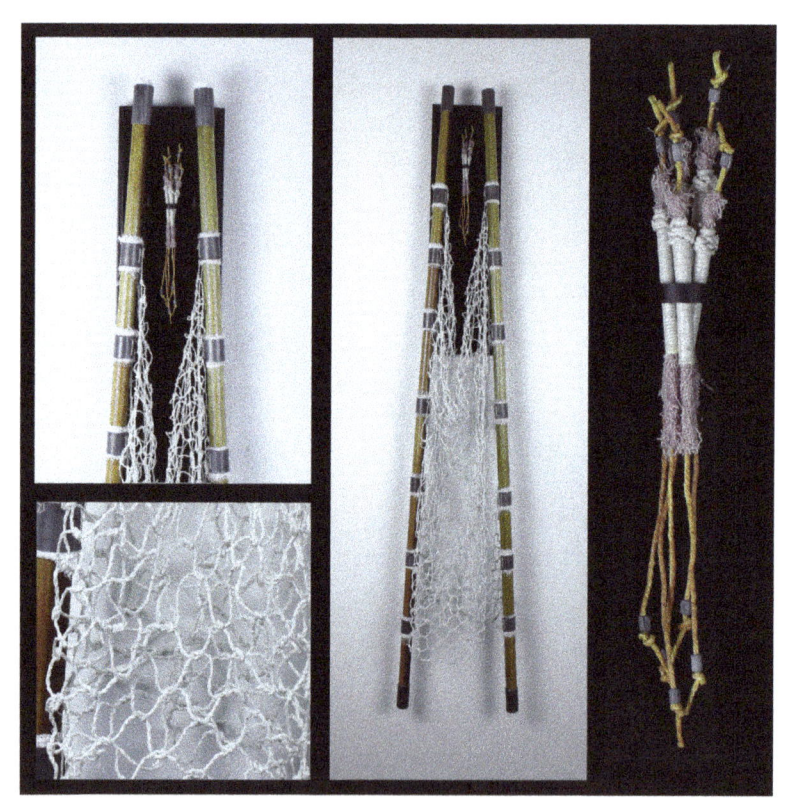

Zac BUSER | MFA 2000
Capture/Released
Lead, gauze, iodine, blued steel, beeswax, twine, polyurethane, and poplar

Matthew KARGOL | MFA 2005
Propped Mass
Watercolor on paper

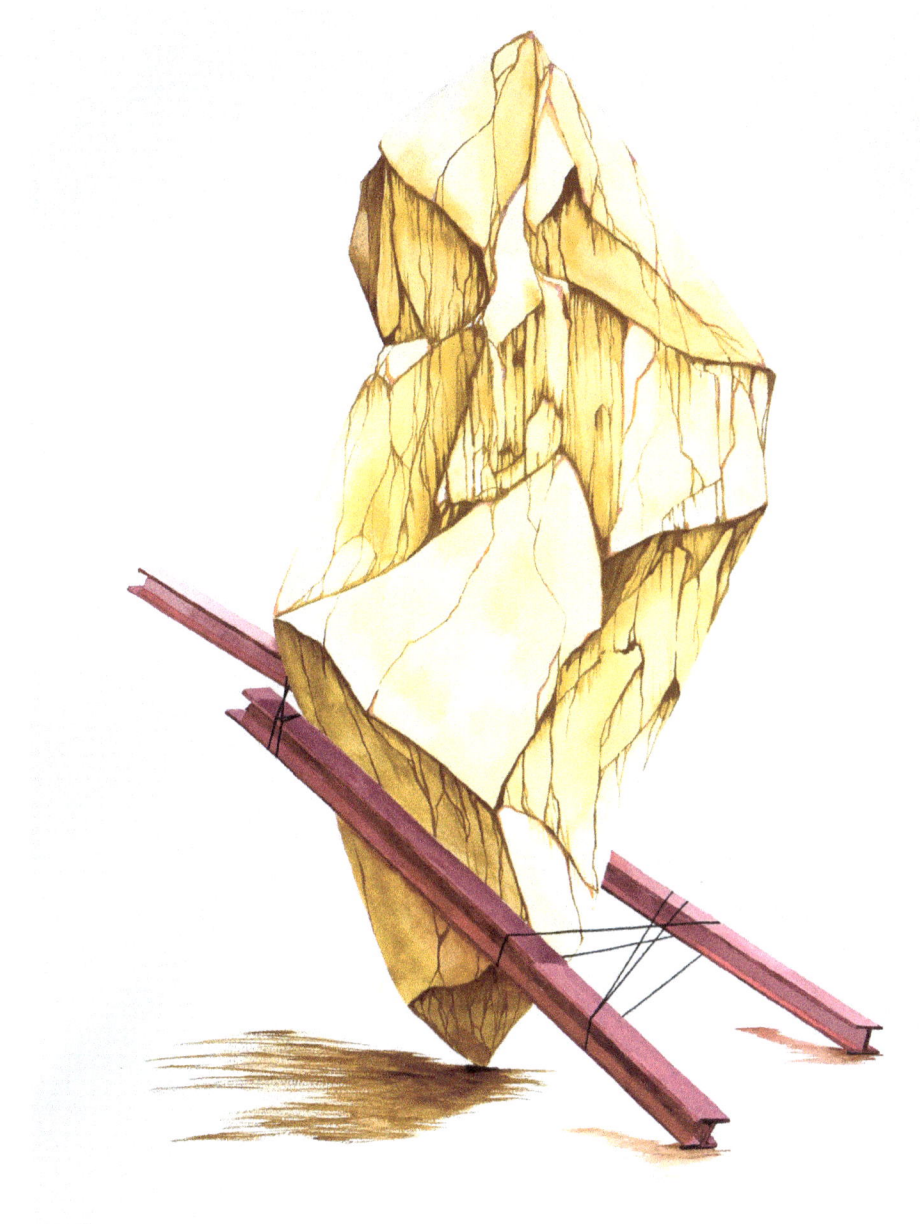

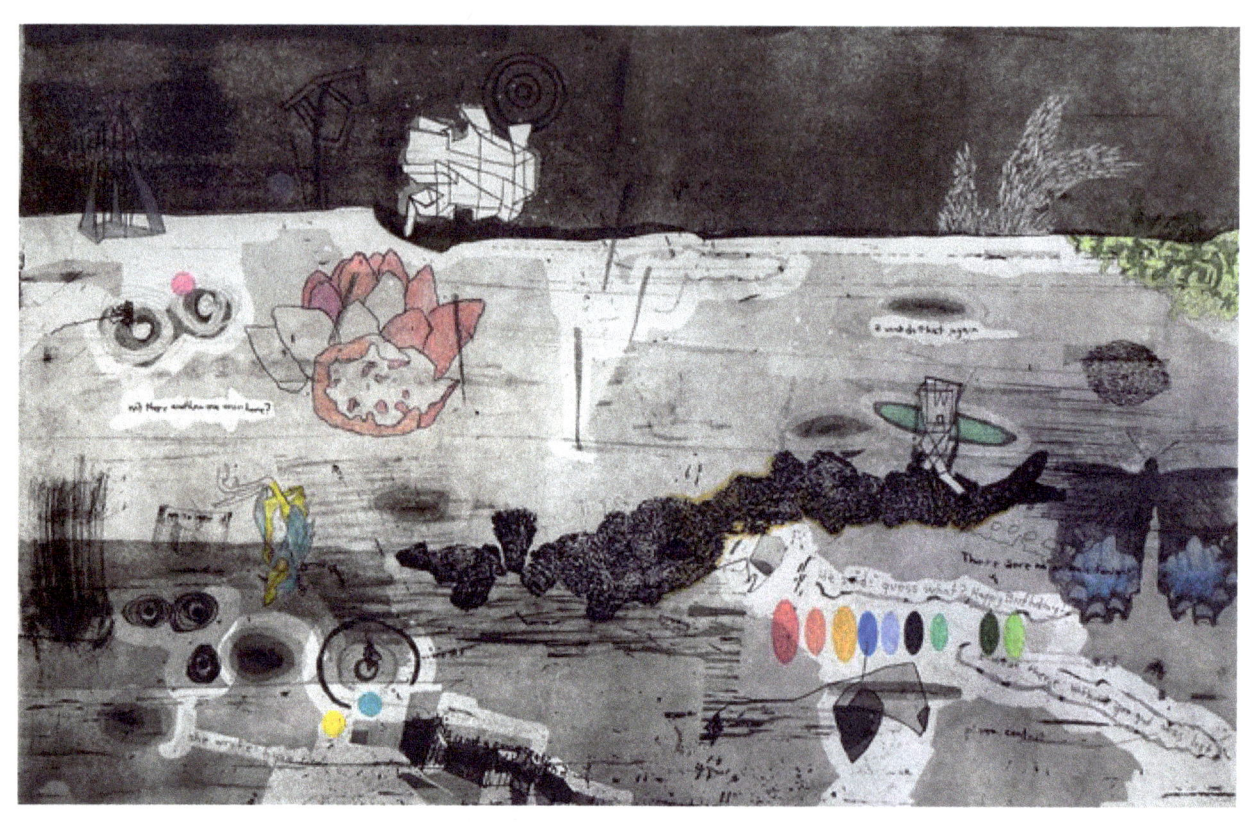

Marty EPP-CARTER | MFA 2009
Color Map for A Considerable Attempt to Make Something Out of Everything
Etching, colored pencil

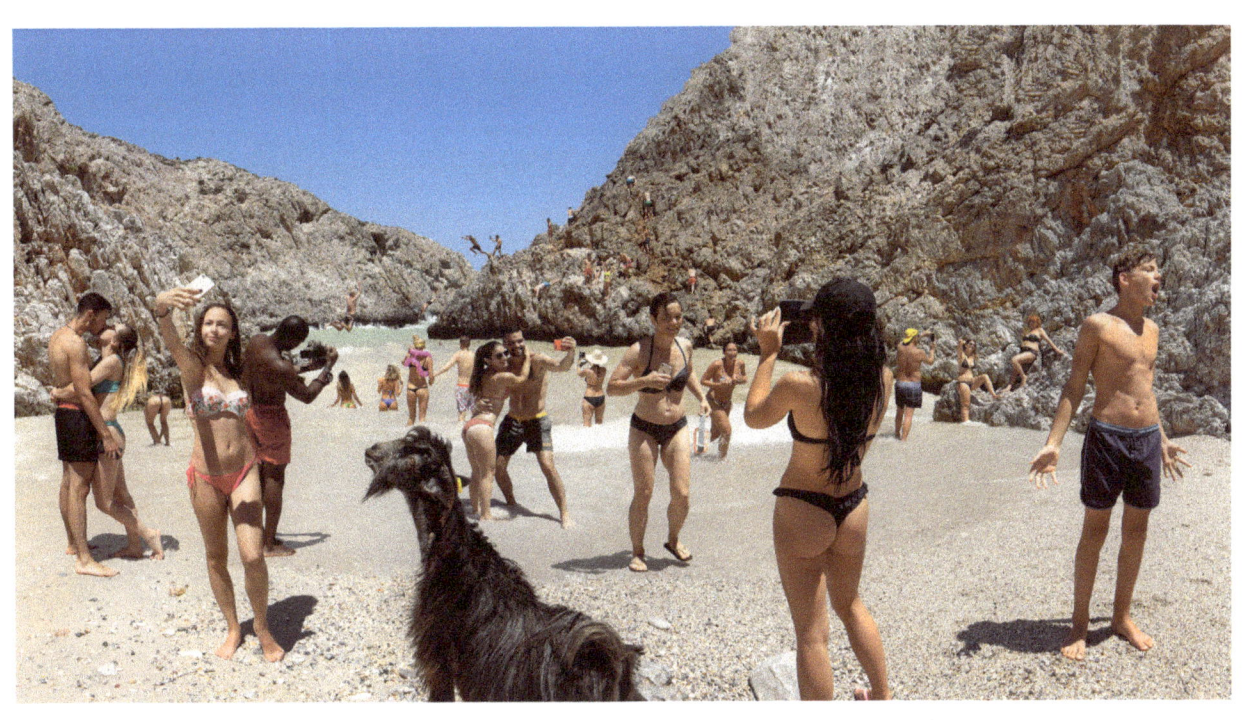

Carrie TOMBERLIN | MFA 2005
You Wish You Were Here
Time distillation on dibond

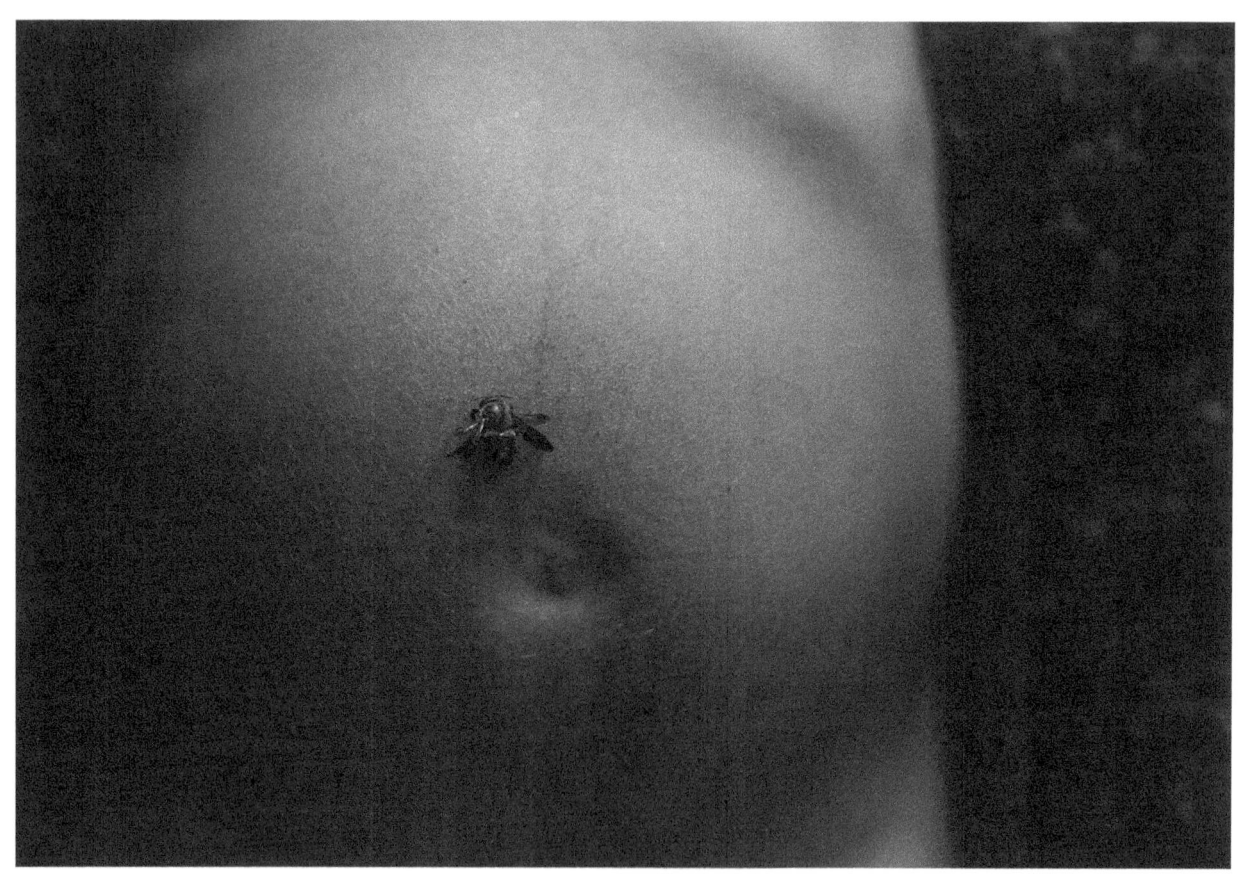

Talbot Easton SELBY | MFA 2006
EOS2
Pigment print

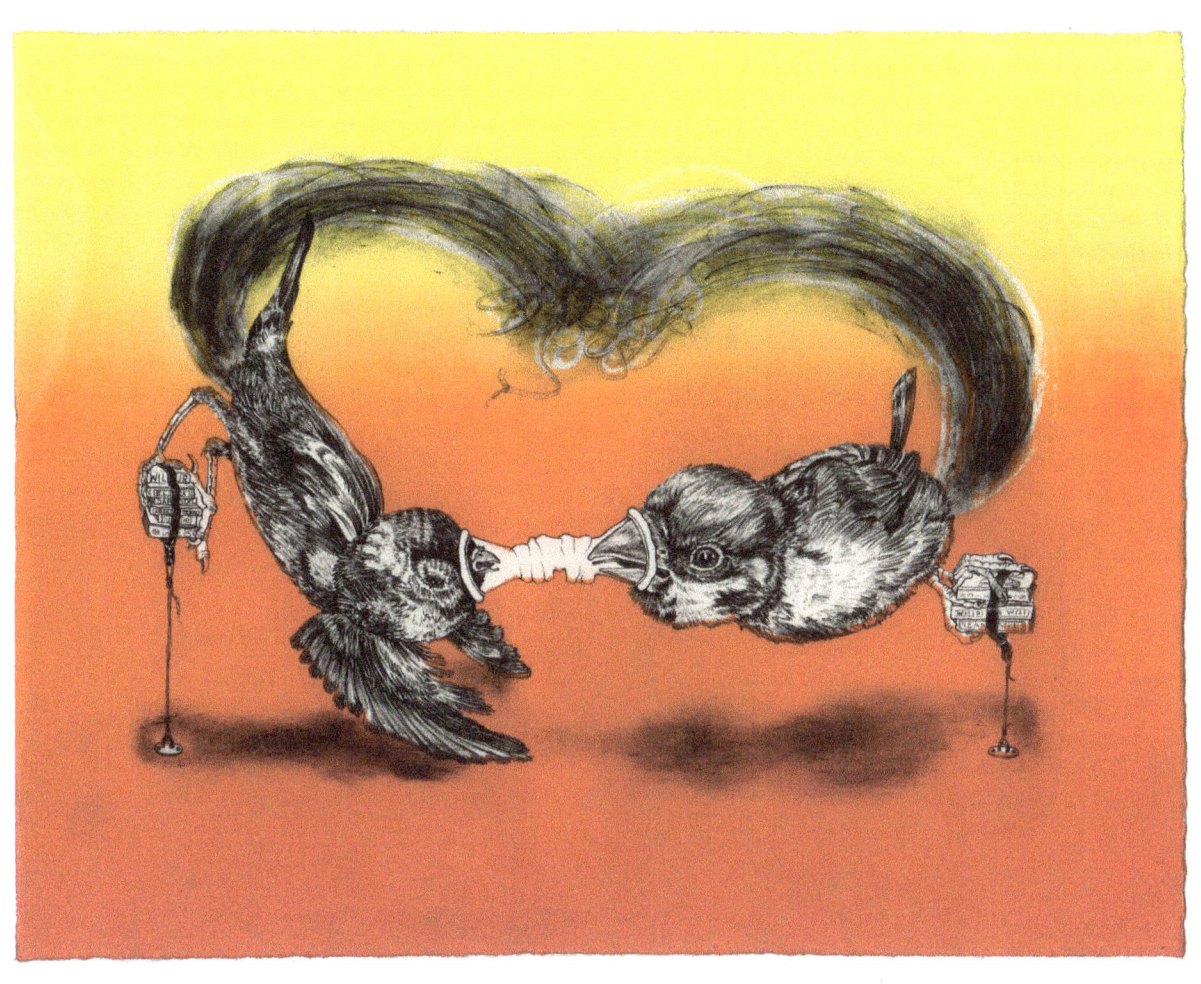

Meghan O'CONNOR | MFA 2007
Gravitational Oscillations
Stone lithography, screenprint

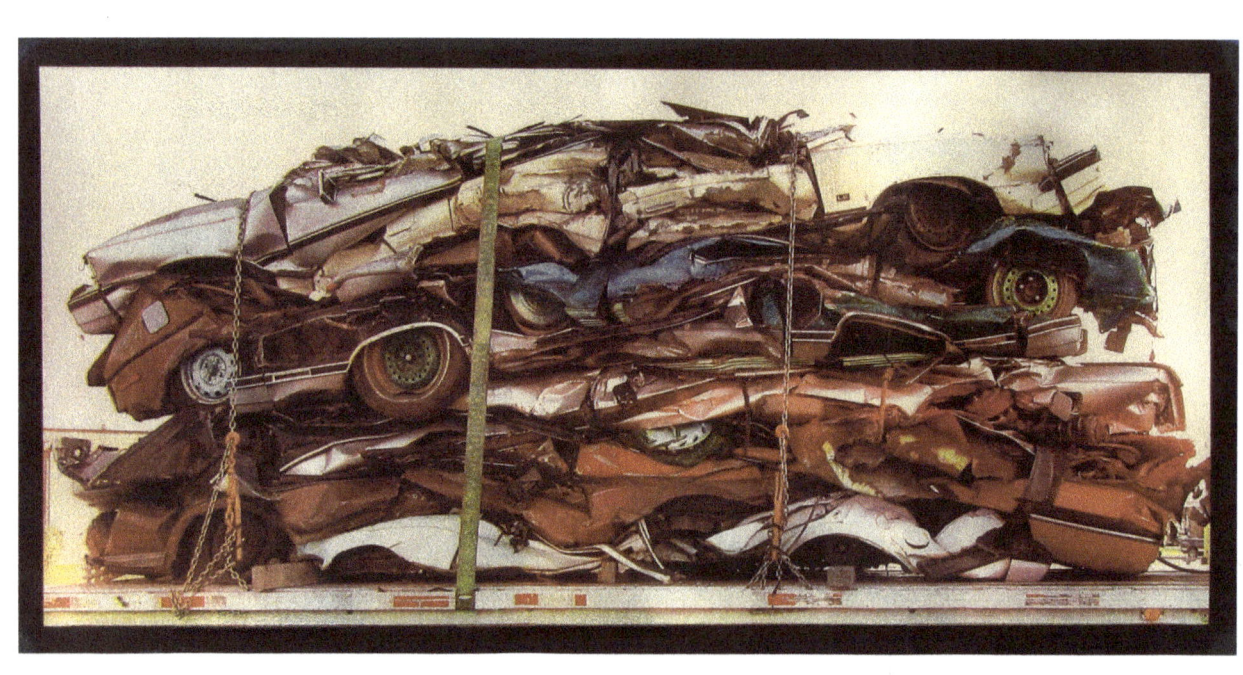

Christina Z. ANDERSON | MFA 2005
Car Squish
Gum bichromate

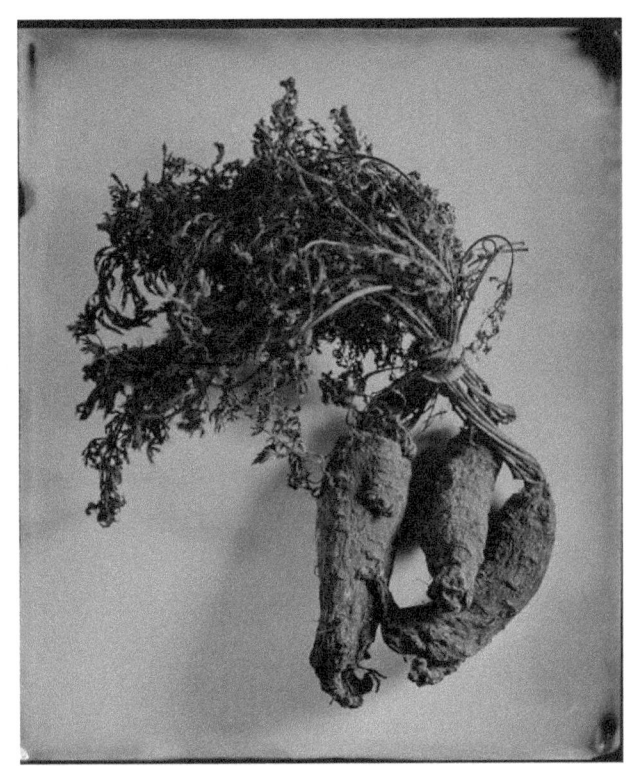

Travis LINVILLE | MFA 2003
Carrots
Wet plate collodion - tintype

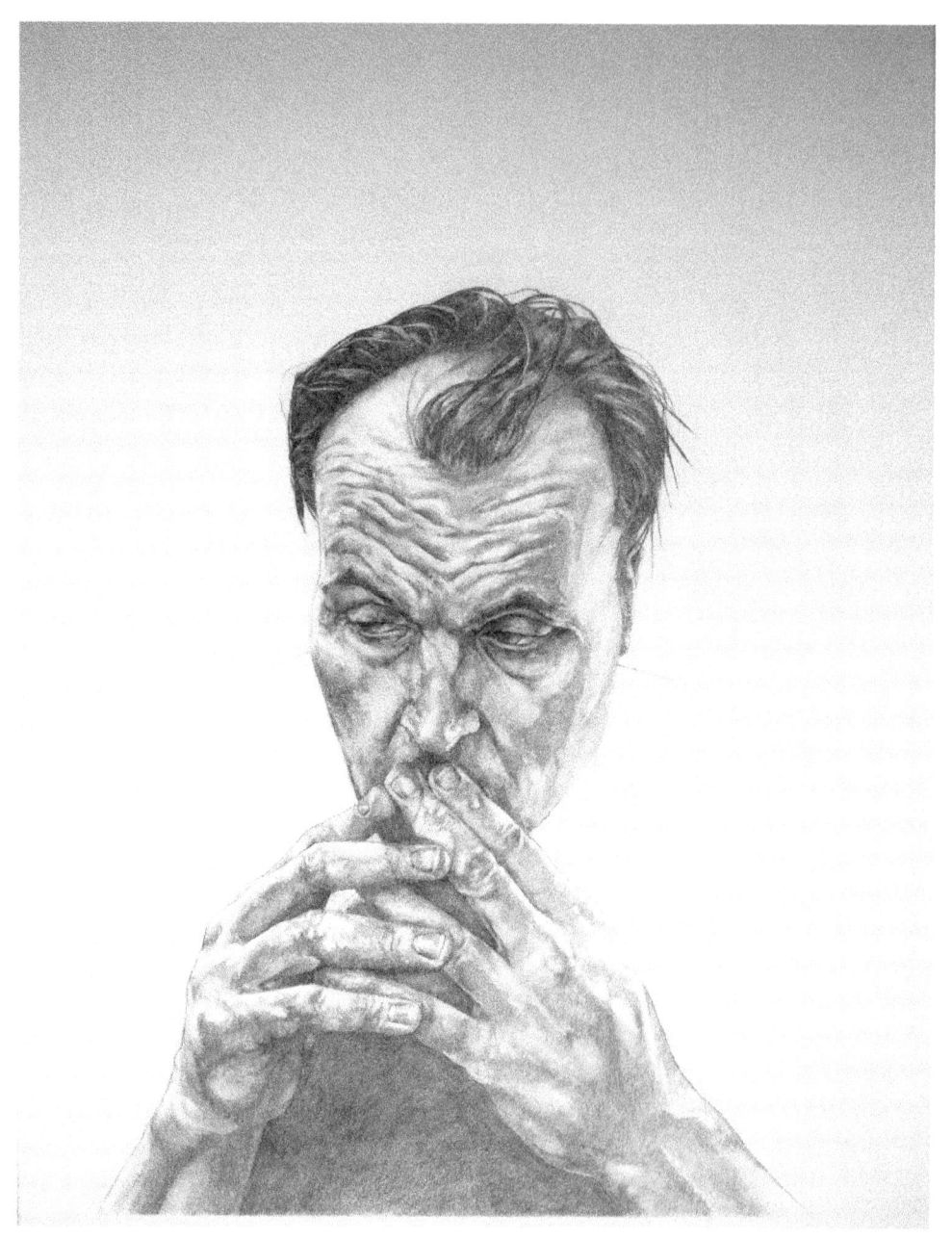

Courtney RICHARDS | MFA 2009
What's Left
Graphite on paper

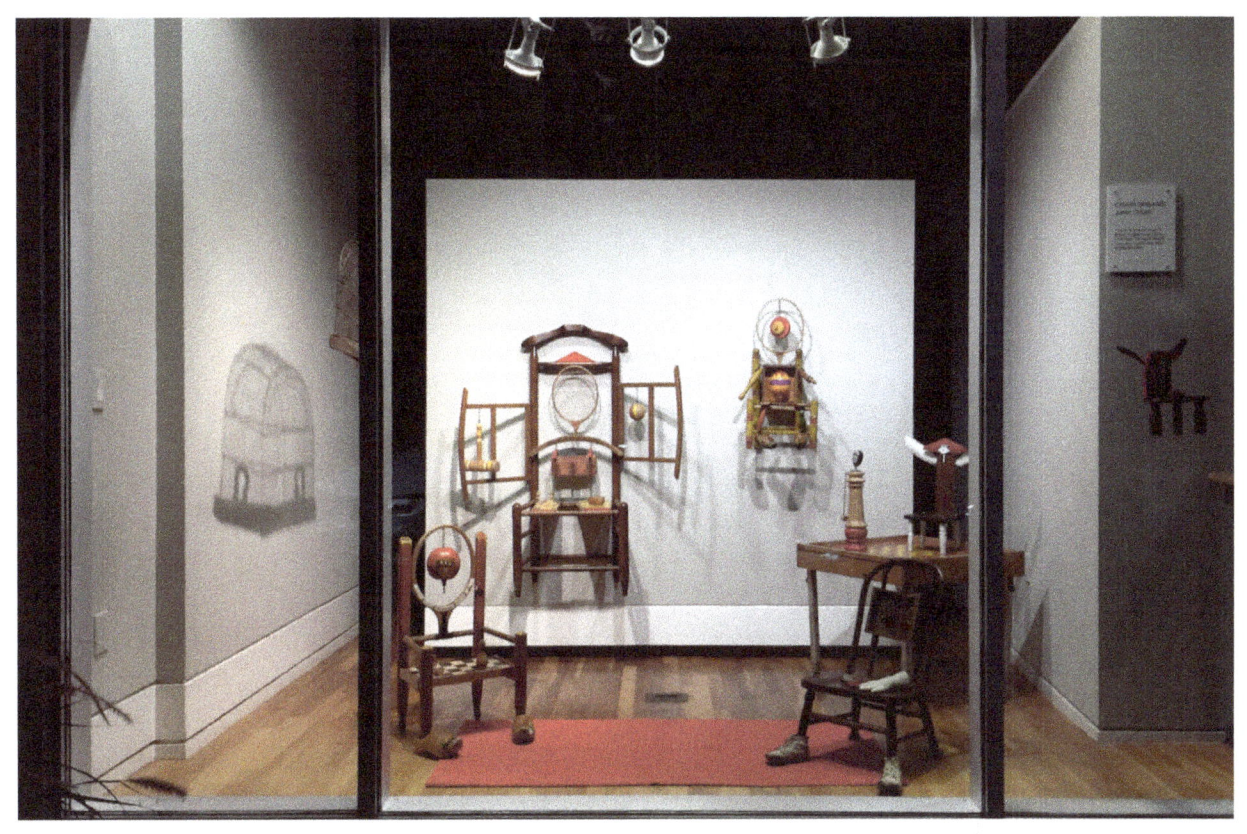

Janet ORSELLI | MFA 2001
Carried Away
Mixed media

Nancy EHLERS | MFA 2008
Atonement
Toned lumen print

Dan MCDONALD | MFA 2006
Oculi cum Sapientia Dens
Steel, glass, rubber, found object

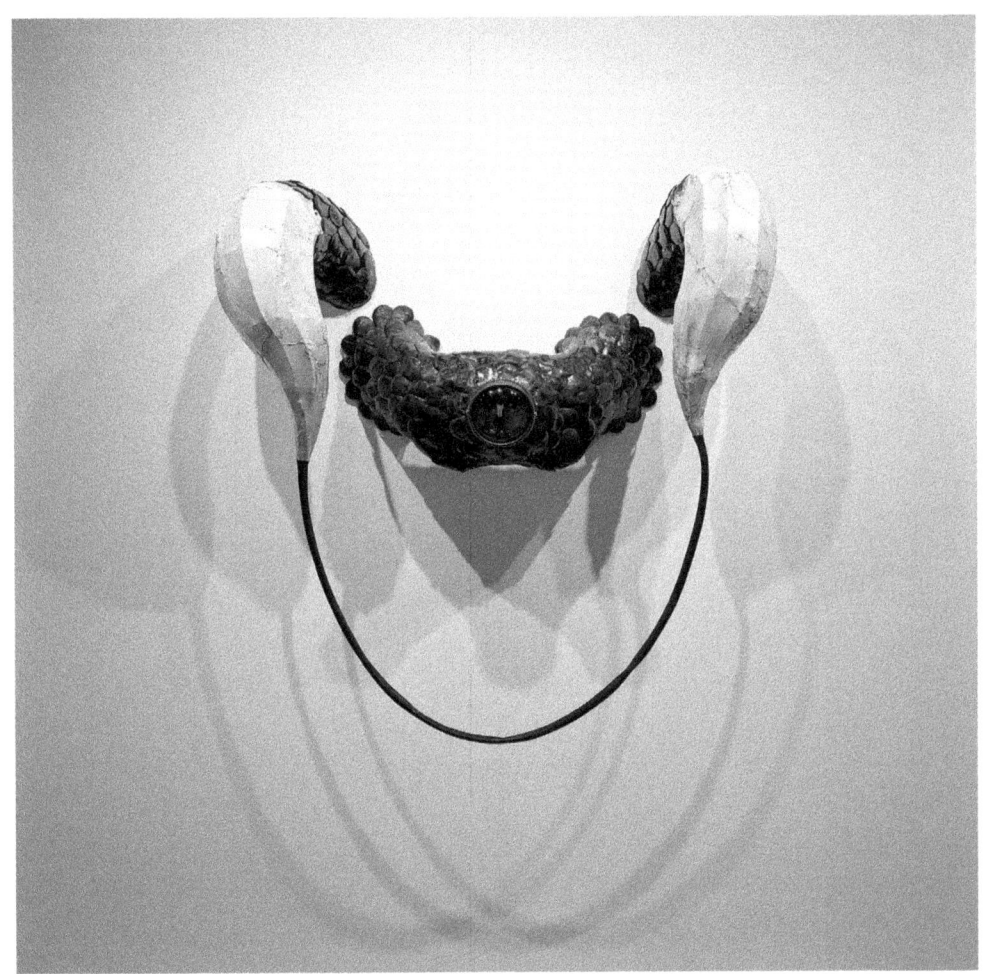

Chad PLUNKET | MFA 2004
Lean
Steel

2010s

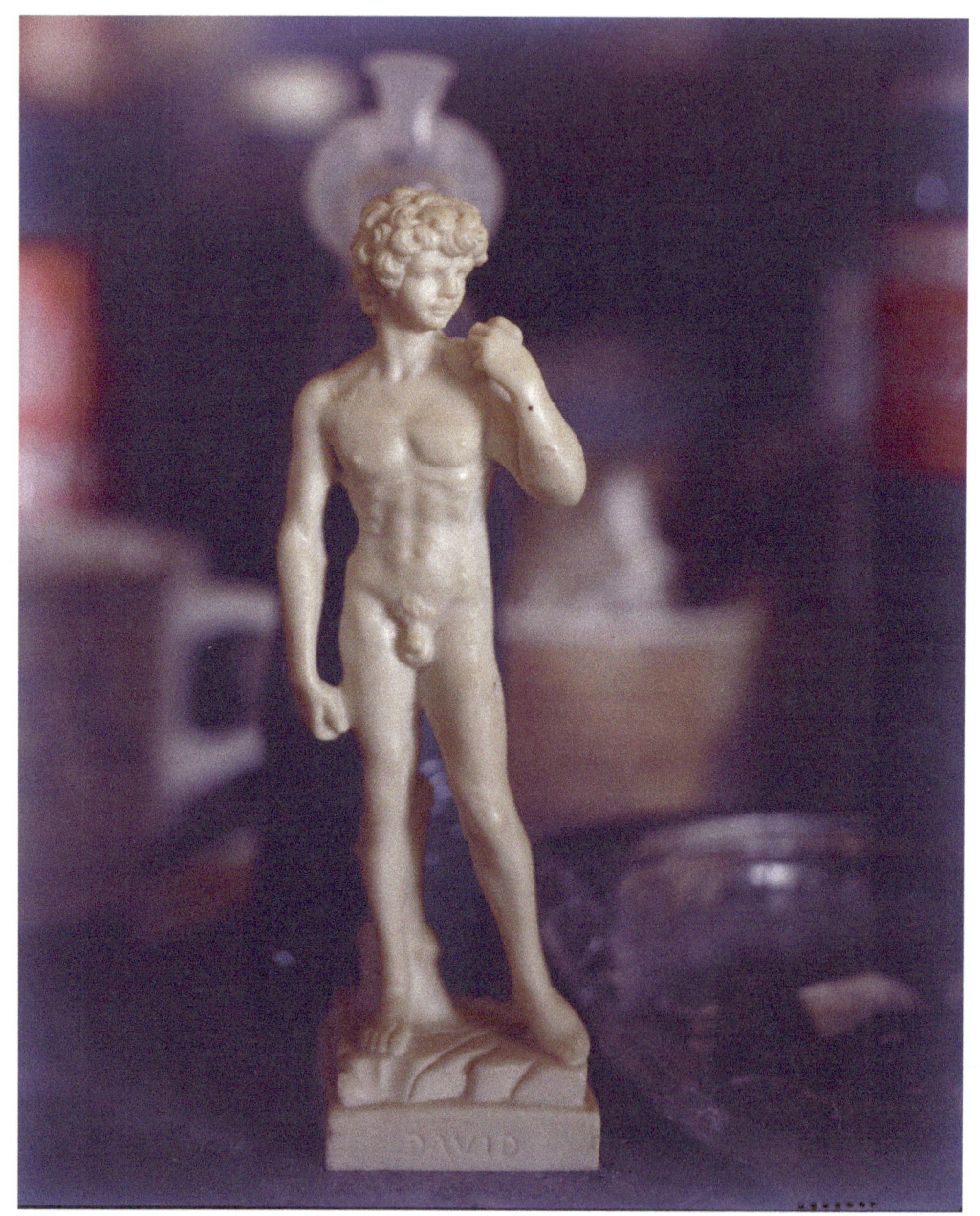

Haley **FLOYD** | MFA 2018
David Study
Scan from 4x5 slide film

Tanna BURCHINAL | MFA 2014
with M. Brett Gaffney-Paul
Touch
Mixed media

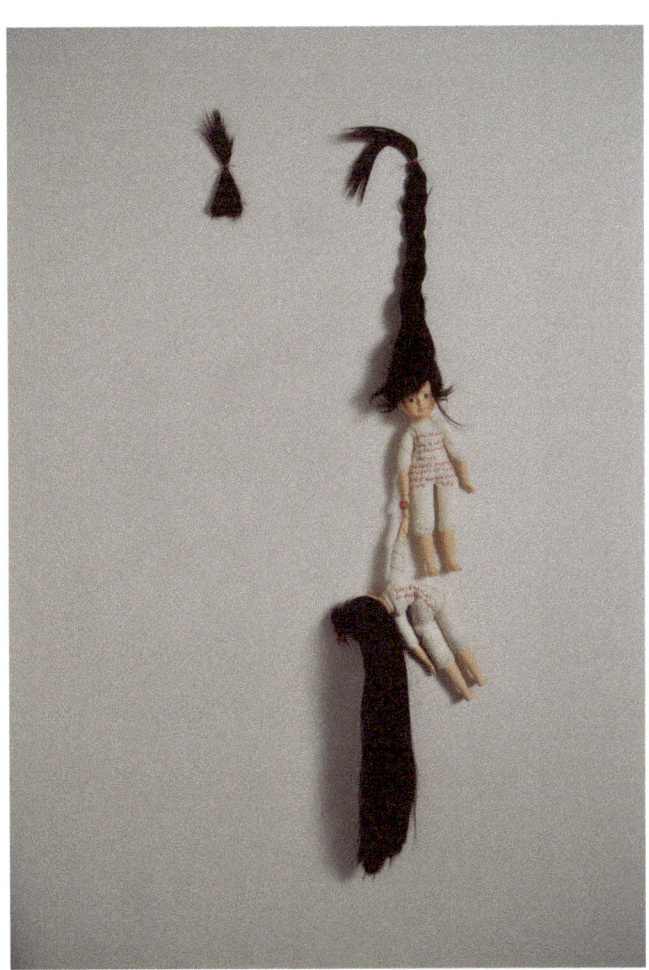

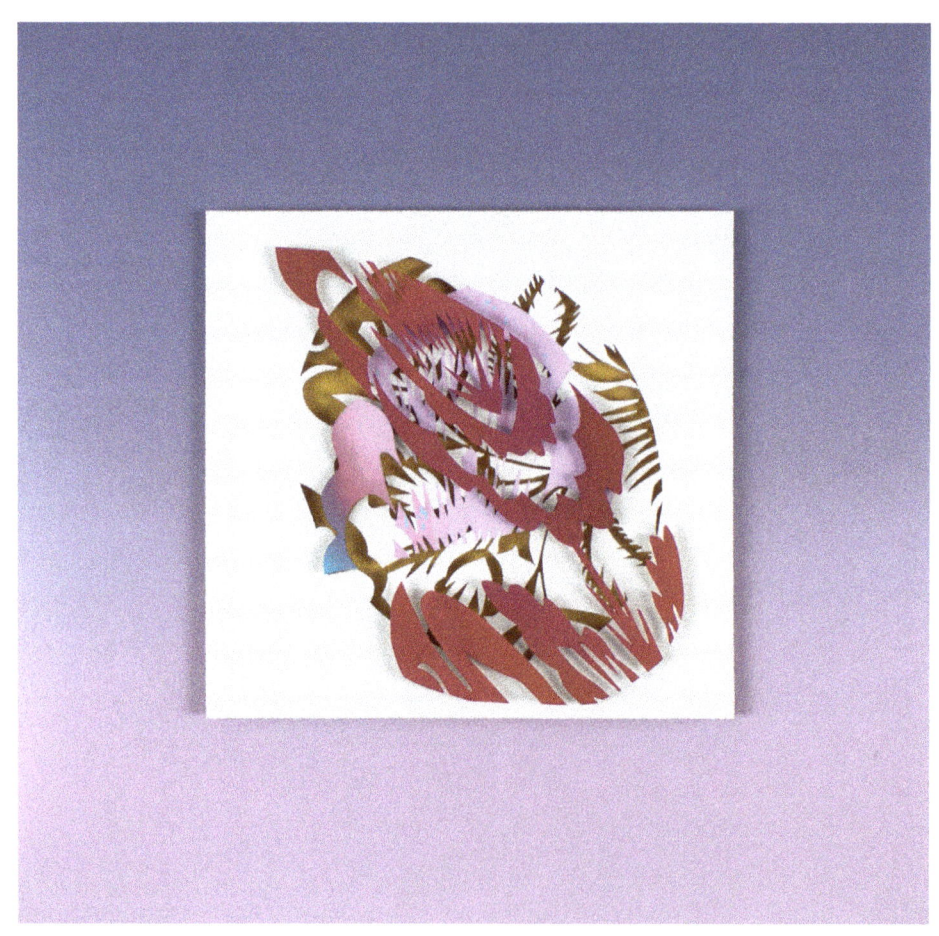

Hanna KOZLOWSKI | MFA 2010
Detangled 1
Oil and atomized acrylic on hand-cut paper

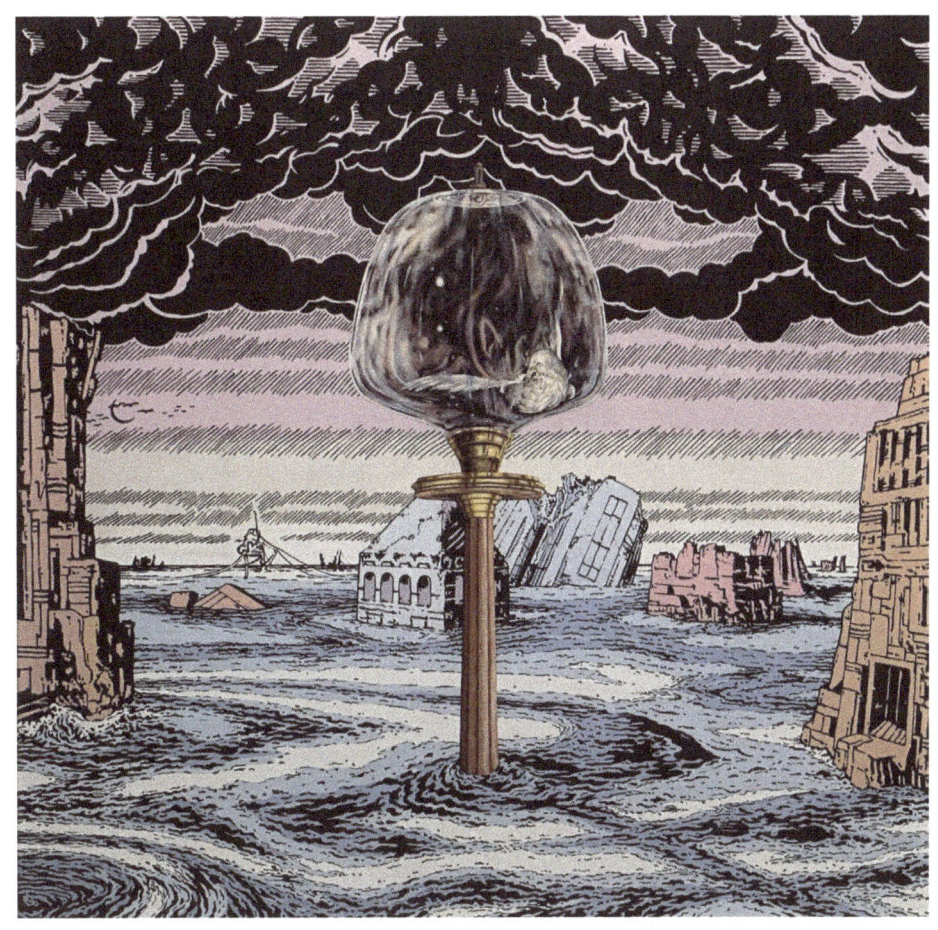

Michael MARKS | MFA 2010
The Stowaway
Oil and acrylic on canvas

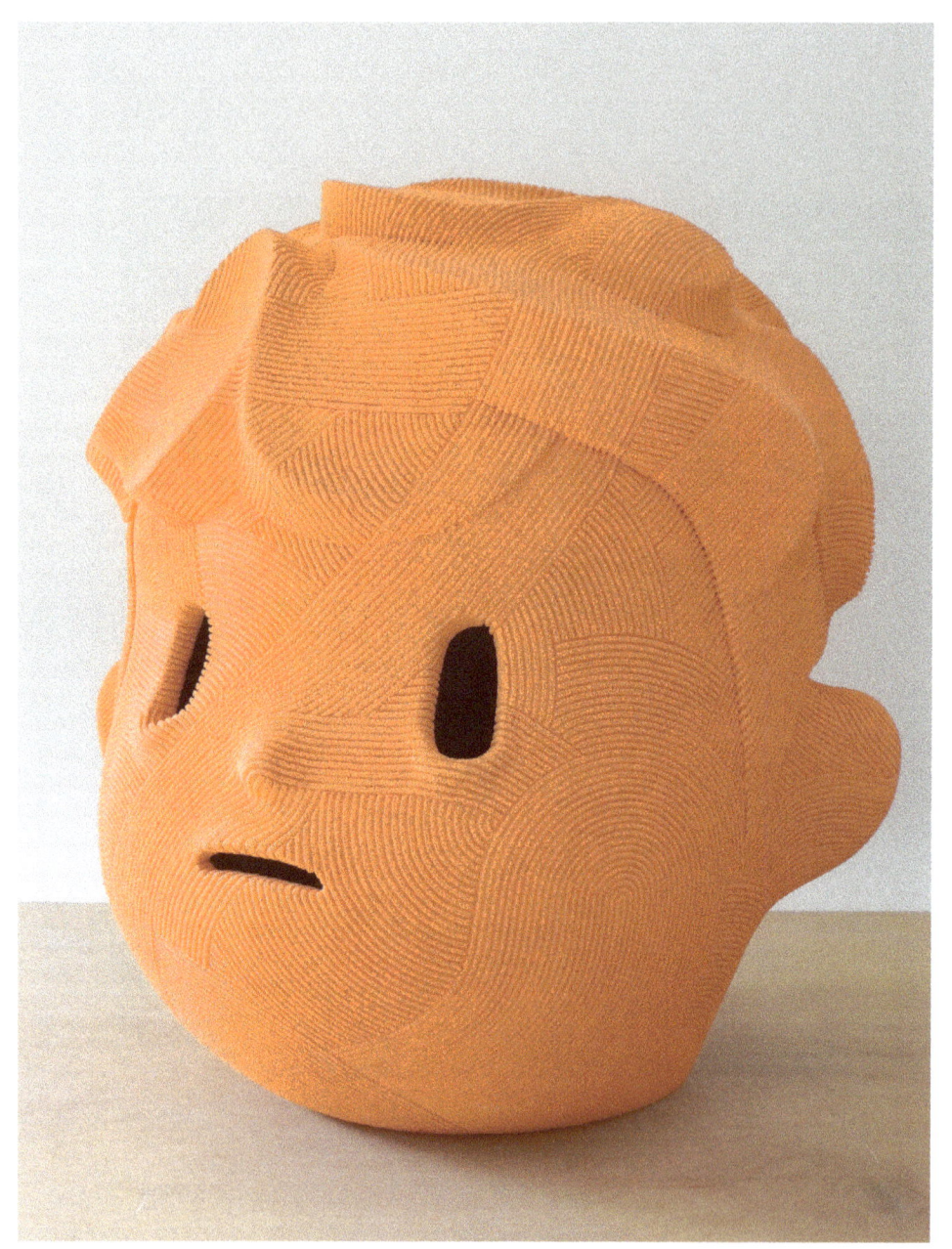

En IWAMURA | MFA 2016
Neo-Jomon: ORANGE
Ceramic

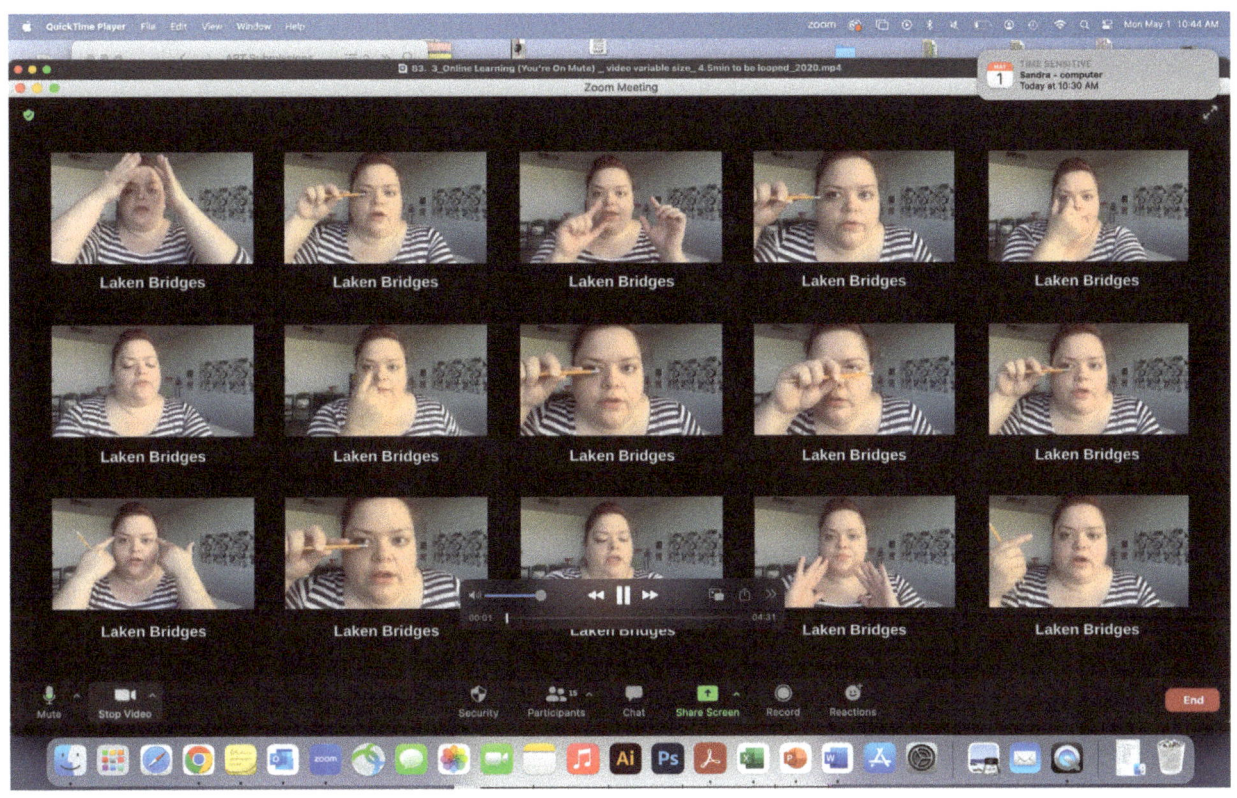

Laken BRIDGES | MFA 2014
Online Learning
Video

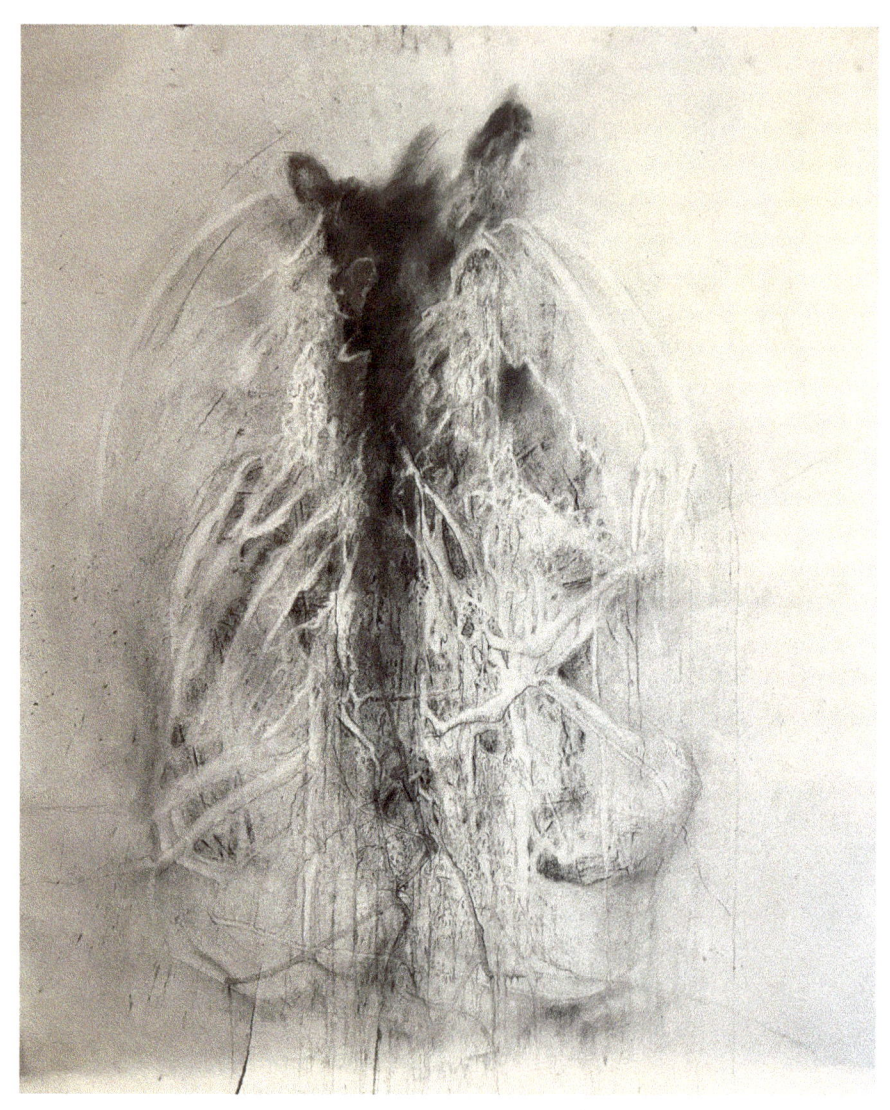

Andrea GARLAND | MFA 2019
Vivisection
Charcoal on embossed paper

Kym DAY | MFA 2017
The New Ambassador
Oil on canvas

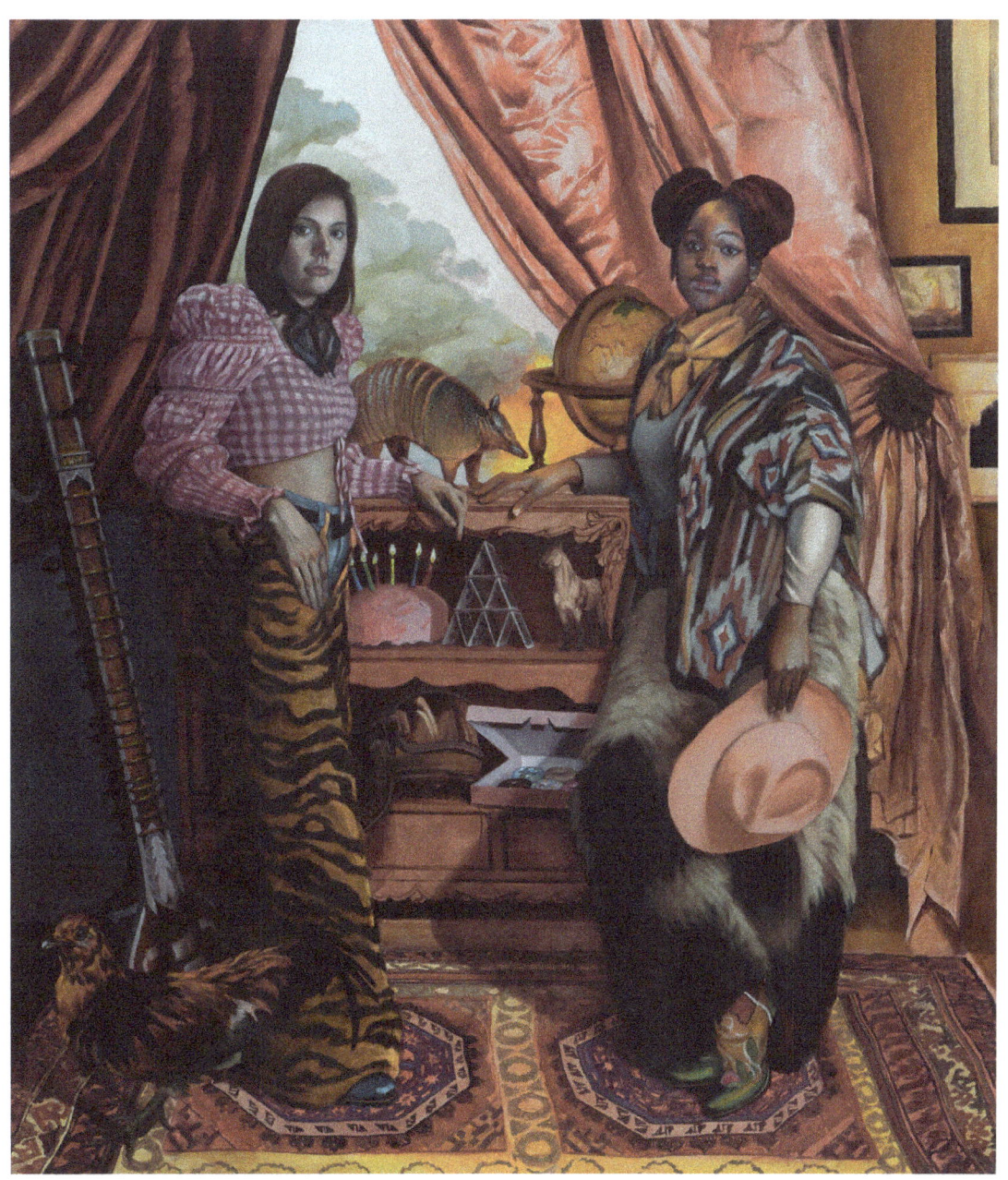

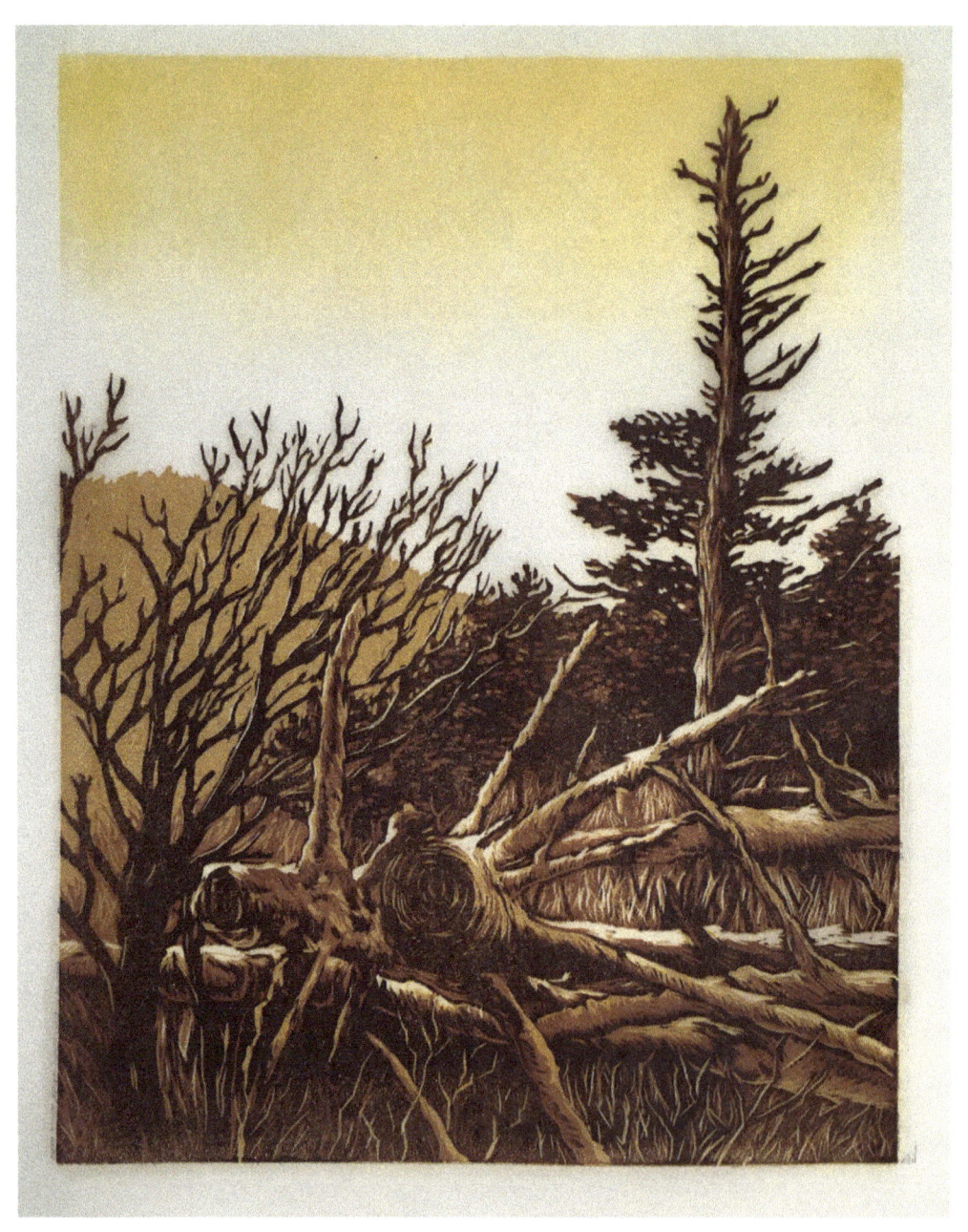

Mandy FERGUSON | MFA 201
Clearing, Mt. Mitchell
Reduction woodcut

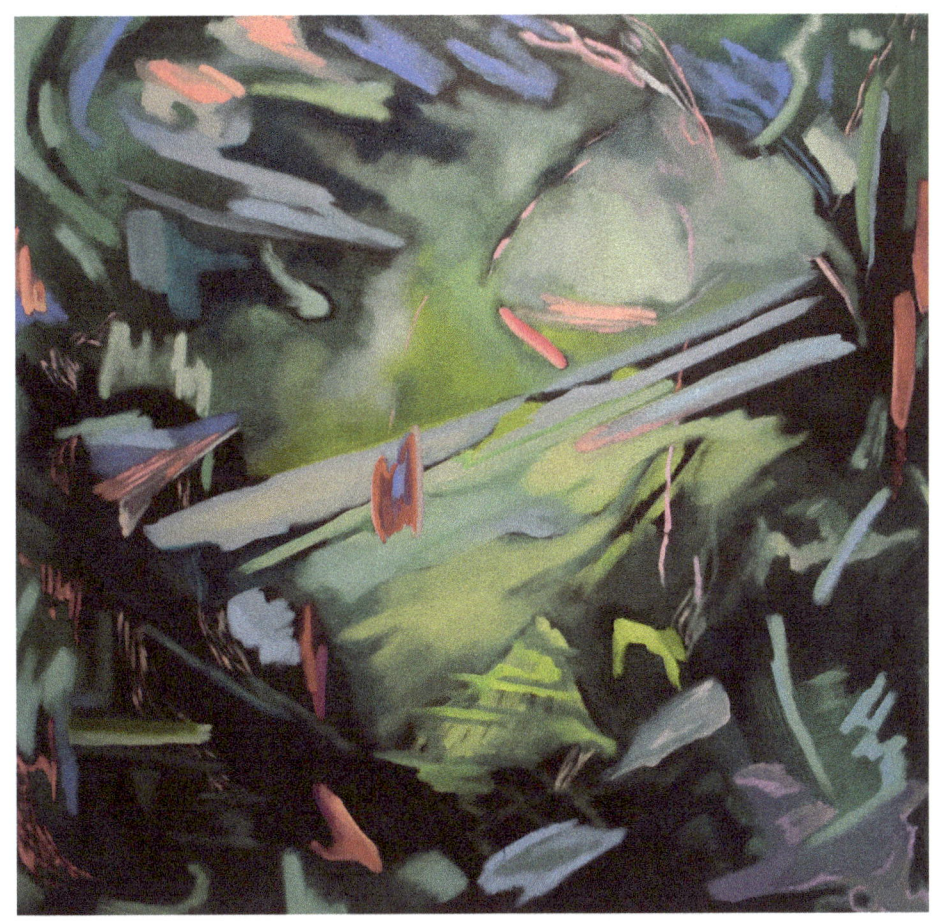

Alyssa Reiser PRINCE | MFA 2013
The River
Oil on canvas

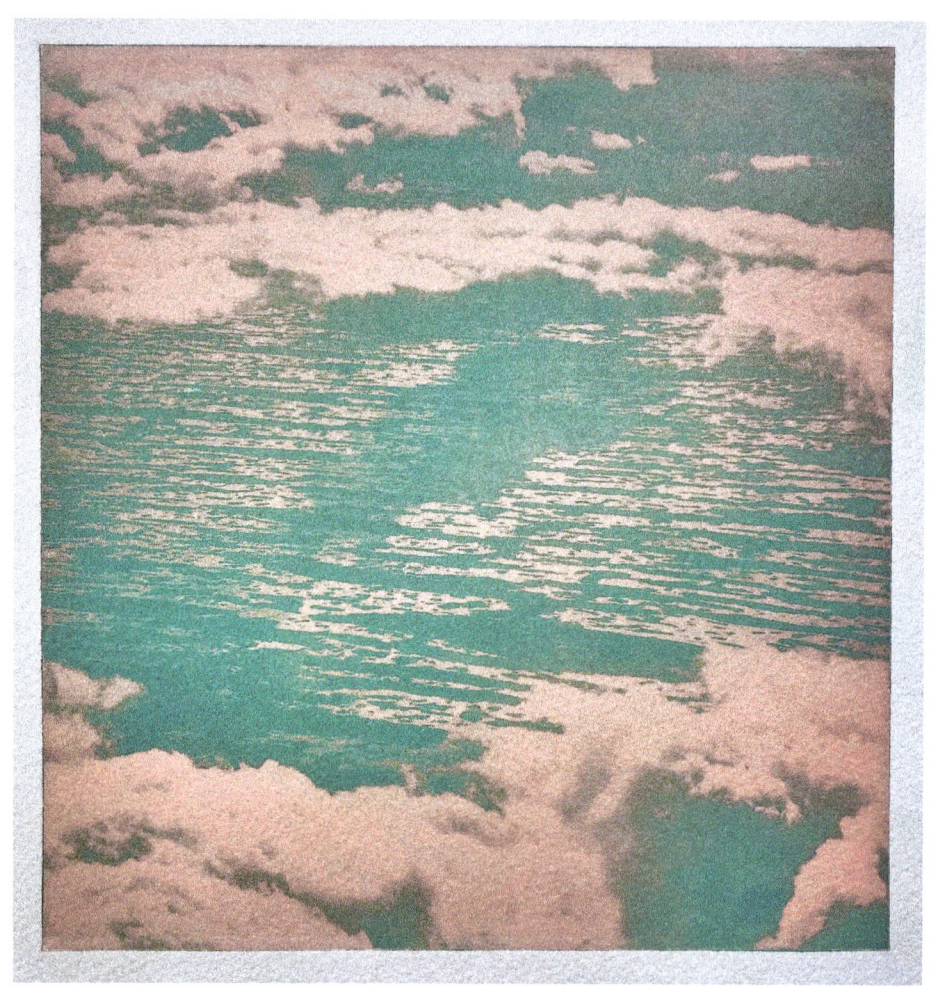

Allison JOHNSON | MFA 2019
Aerial Glades, Pink
Photopolymer gravure print
on Somerset Velvet paper

Owen RILEY | MFA 2010
Red, White and Blue
Photography print

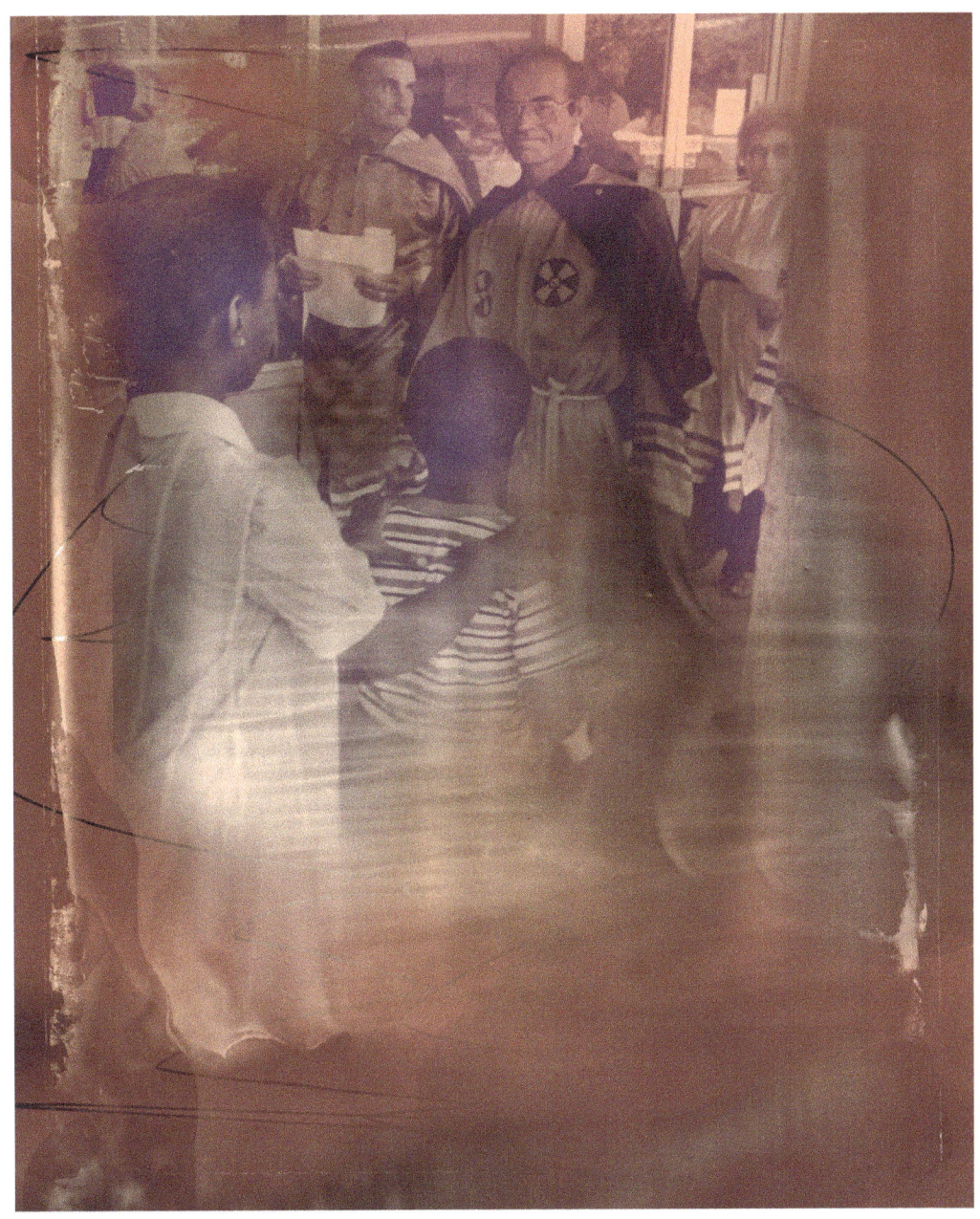

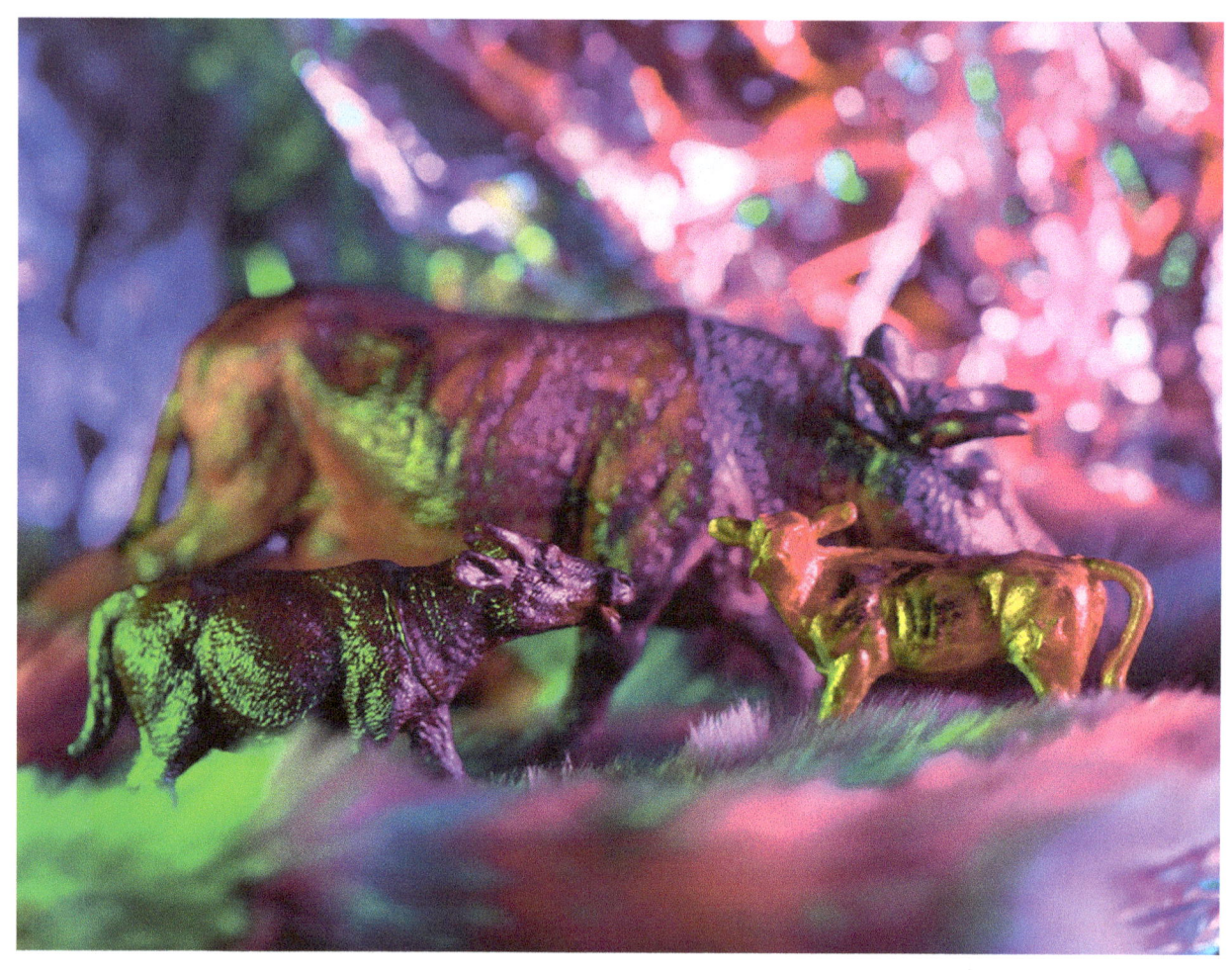

Aubree ROSS | MFA 2013
Plains of Color
Photography print

Ashan PRIDGON | MFA 2018
Everyday People, Faux Locs, Crochet & Braided Updo
Stoneware ceramic

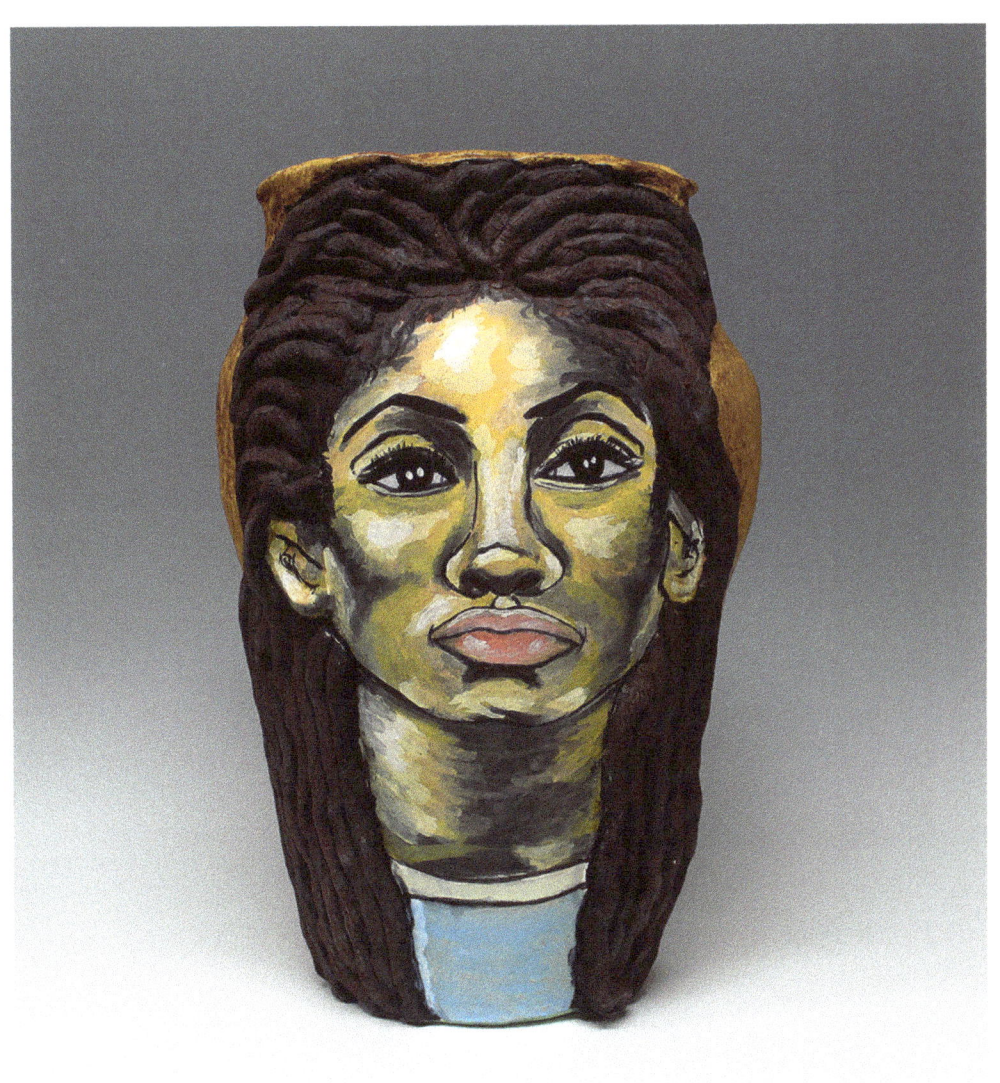

Amanda MUSICK | MFA 2018
A Walk Apart 1
with Meg Roussous
Archival inkjet print

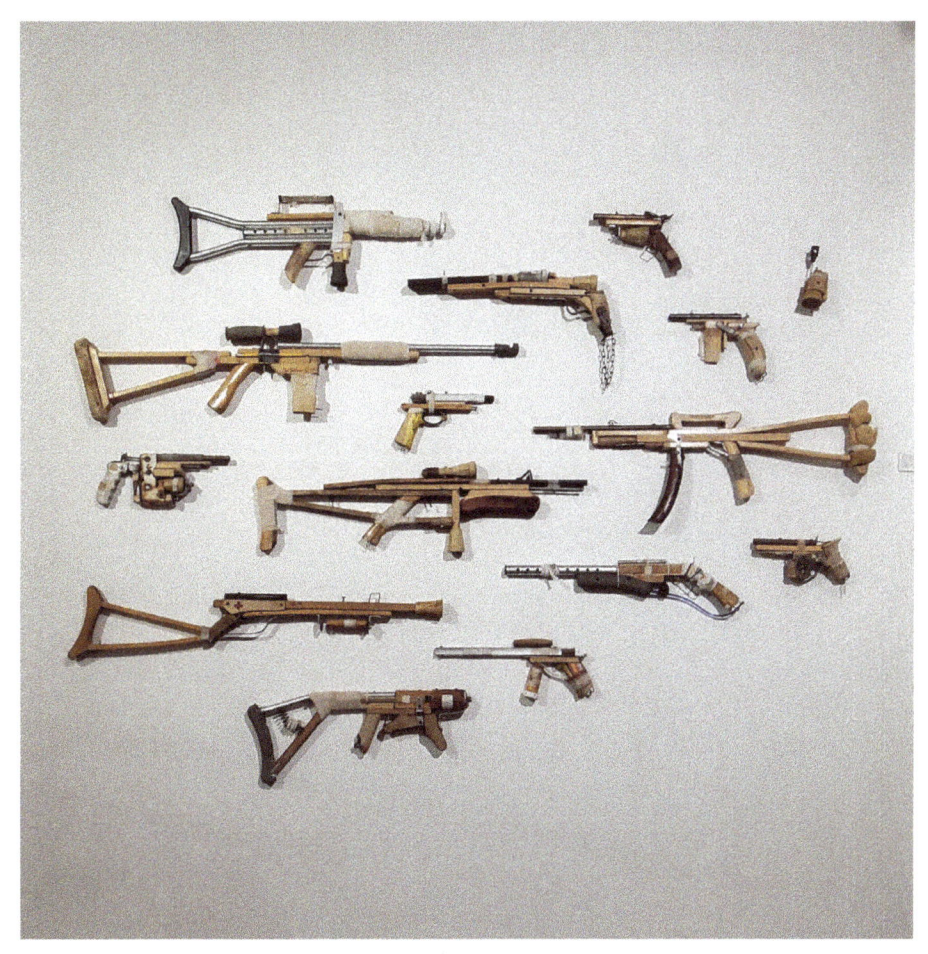

Carey MORTON | MFA 2018
Loaded Objects
Crutches, medical equipment, broken machinery

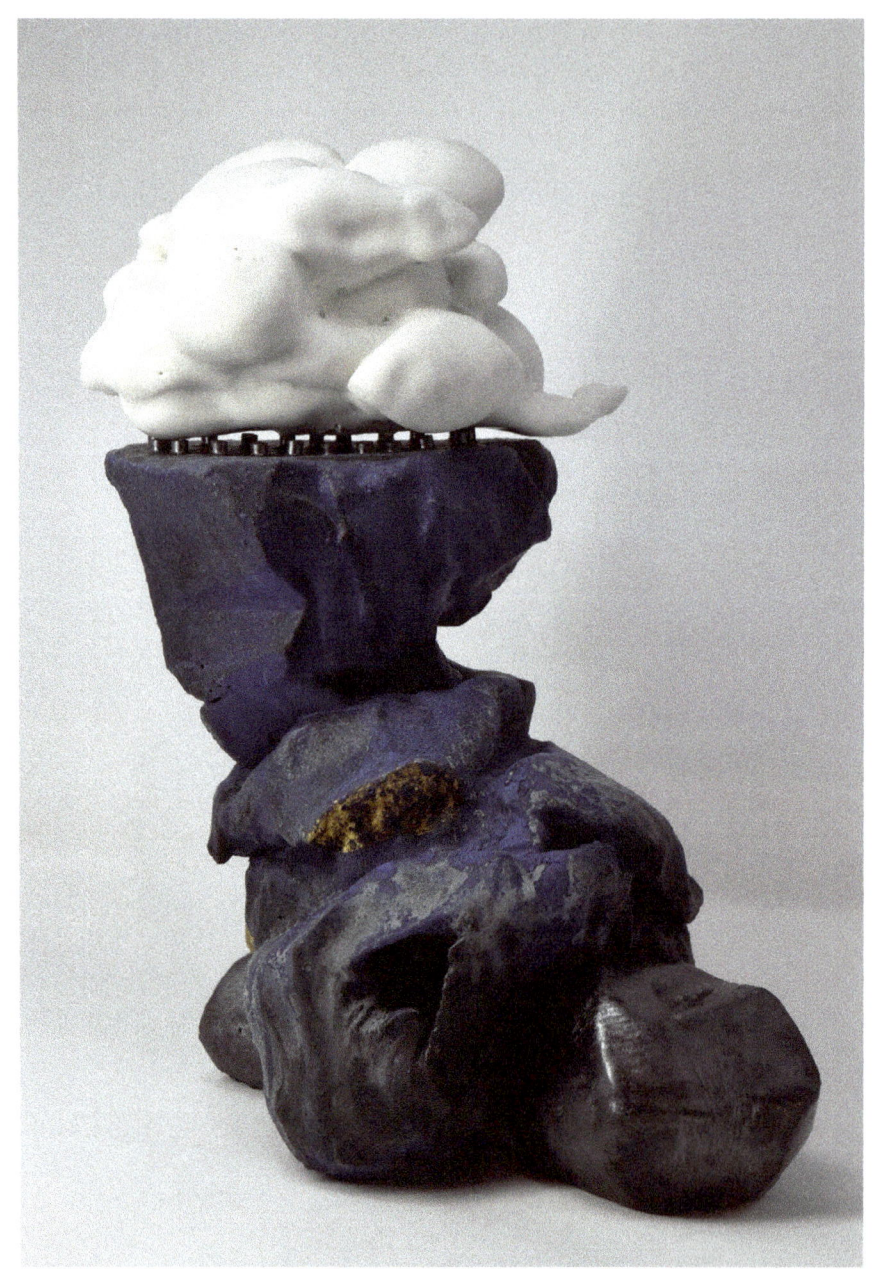

Deighton ABRAMS | MFA 2016
Cliff of Perception
Stoneware, porcelain, luster

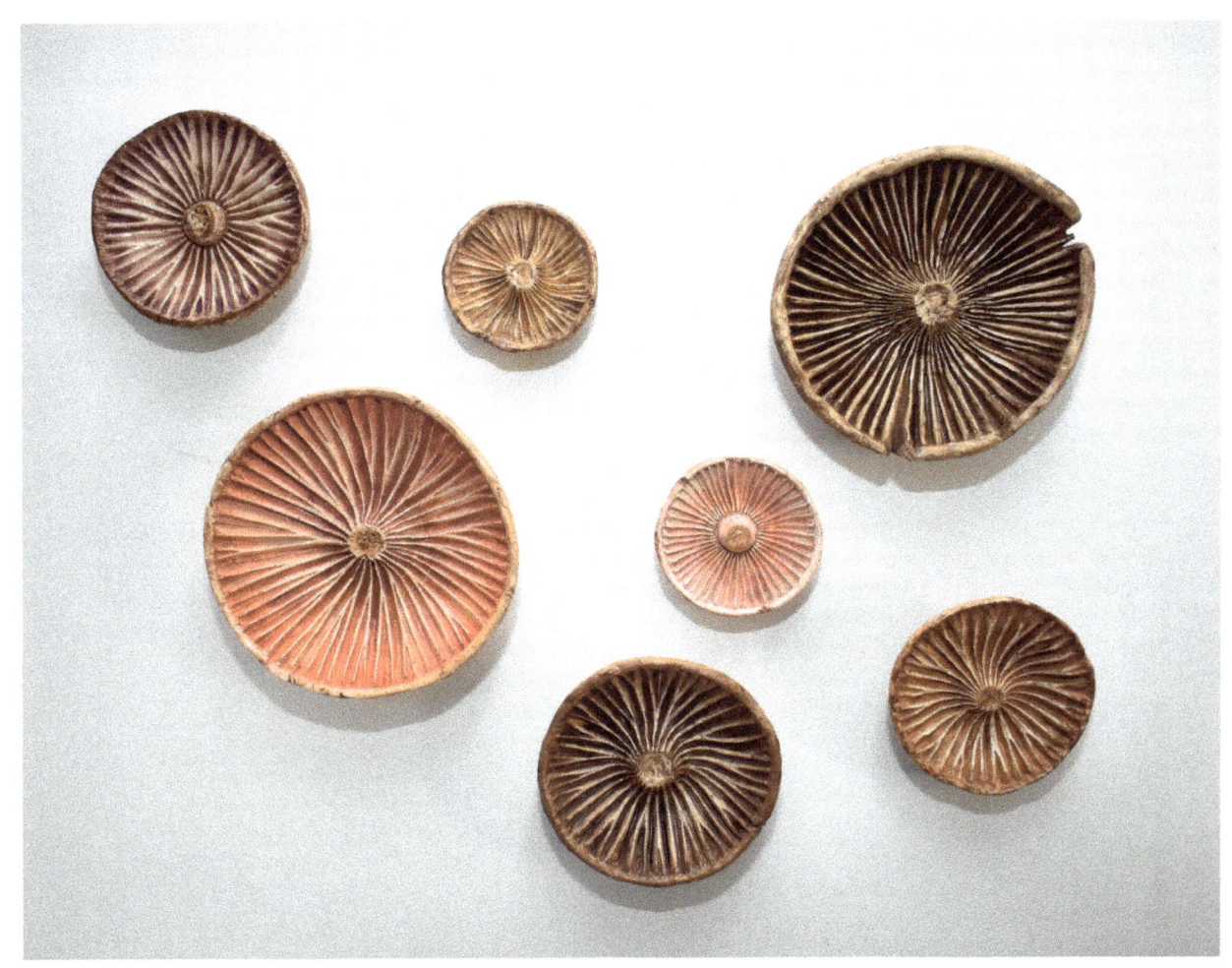

Nina KAWAR | MFA 2014
Agaricales
Porcelain

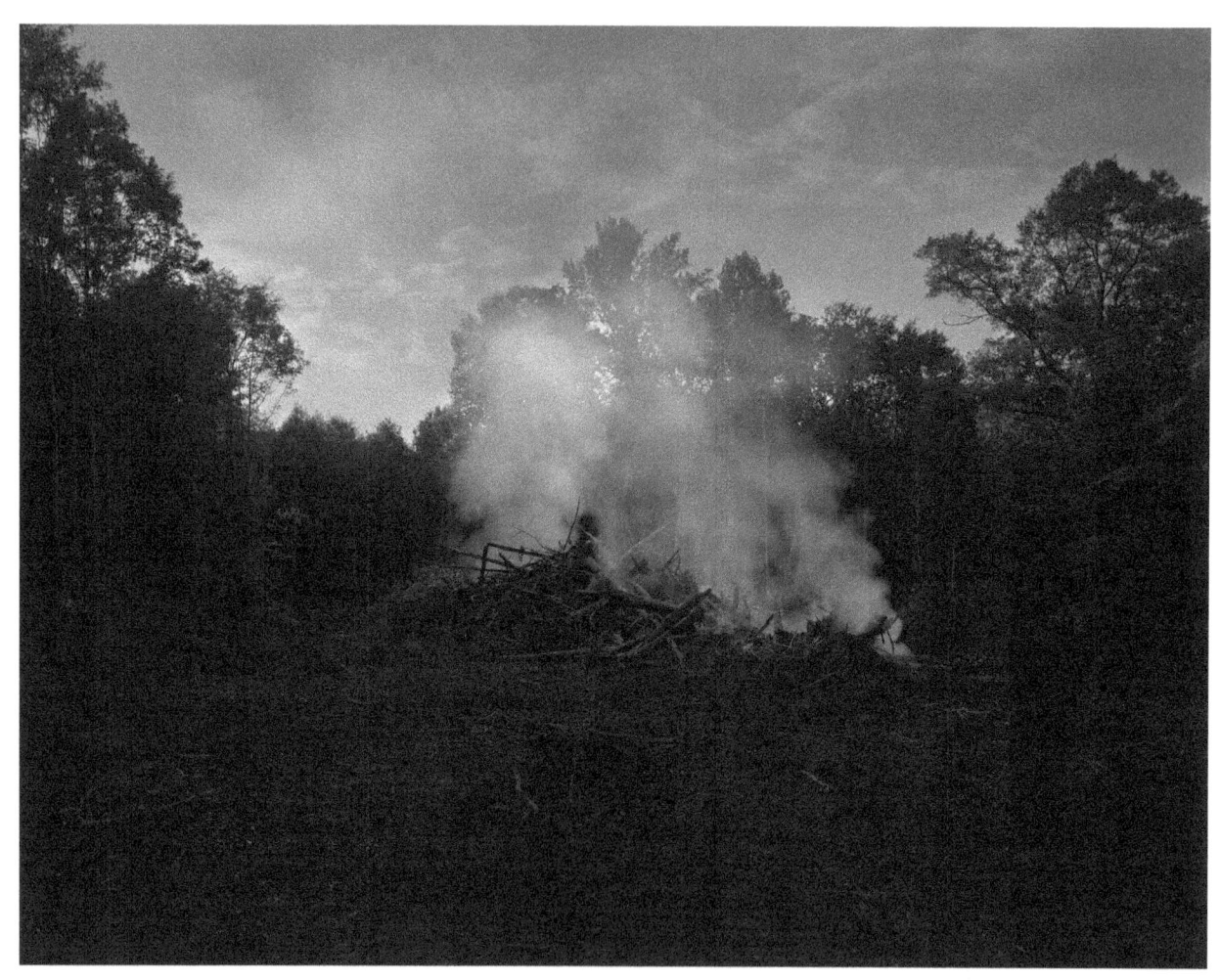

Zane LOGAN | MFA 2011
Jug Factory Burn
Inkjet print

David ARMISTEAD | MFA 2013
Meditation (making a mark)
Wood, canvas, acrylic

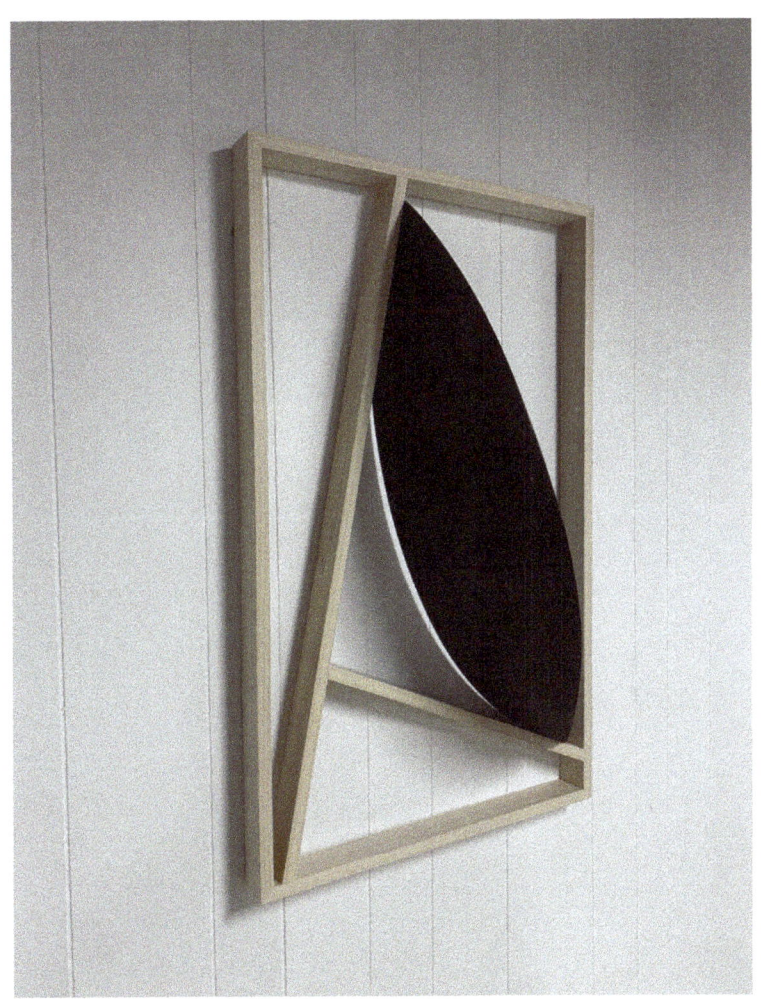

2020s

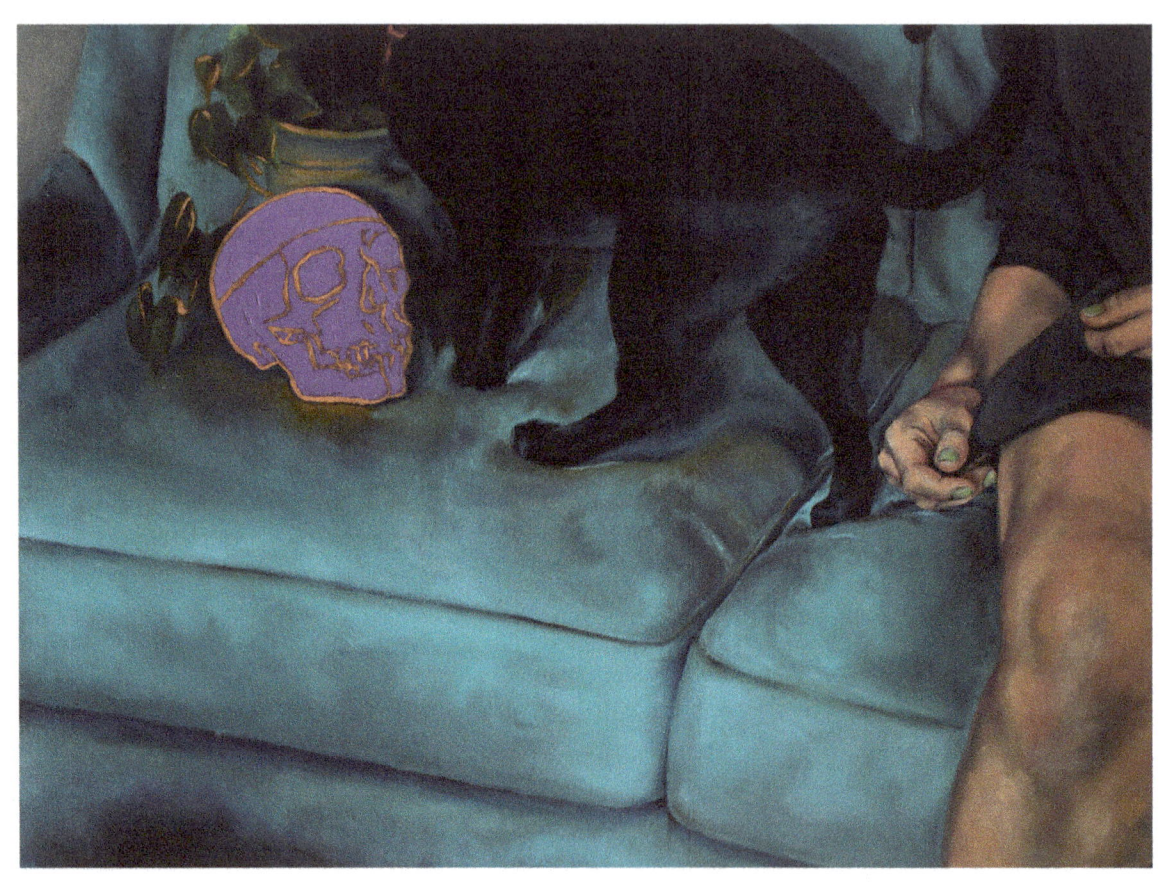

Ashley RABANAL | MFA 2020
Morning Ghost
Oil on Arches Paper

Lori Brook JOHNSON | MFA 2021
Winter Coat
Graphite

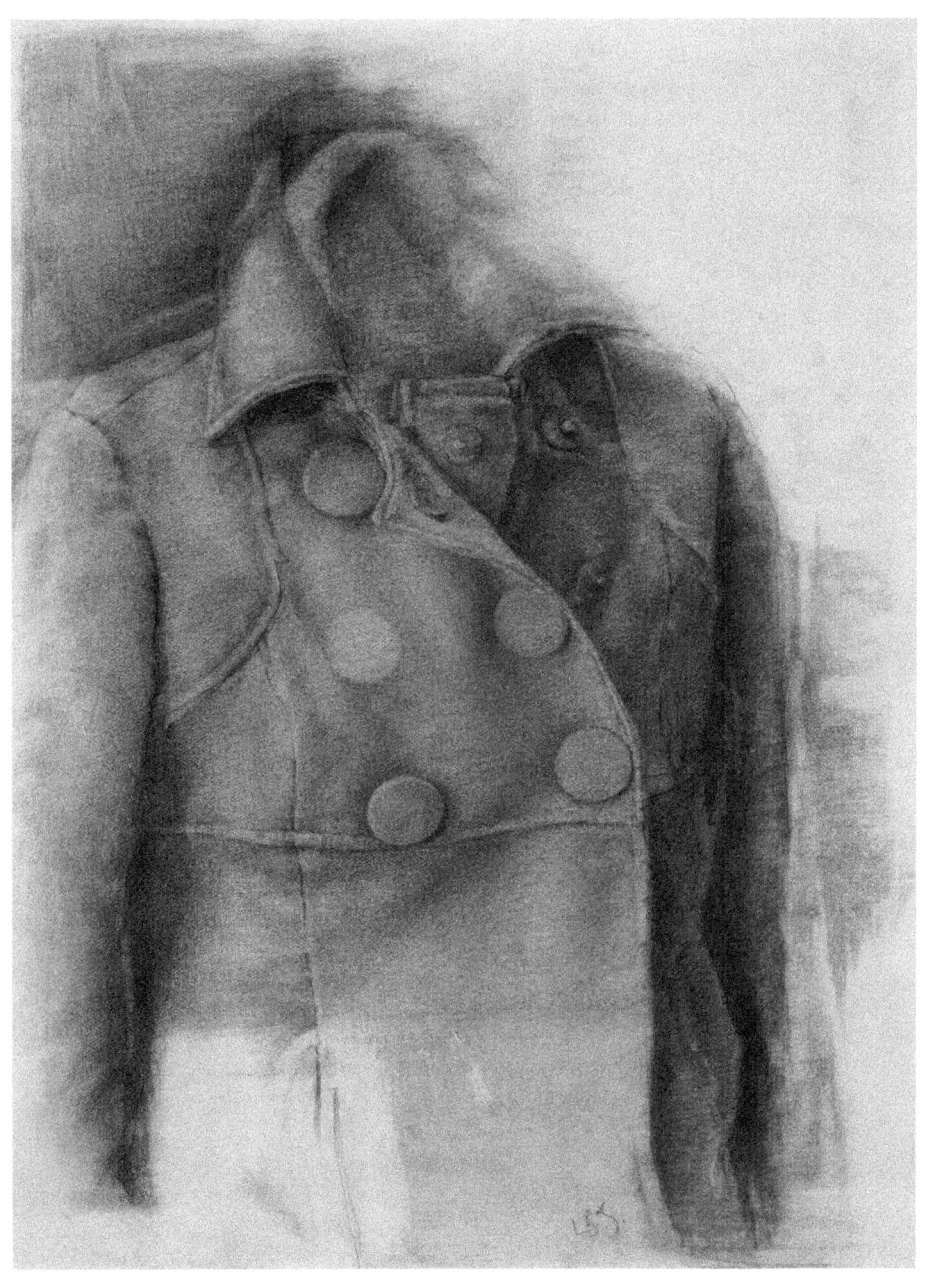

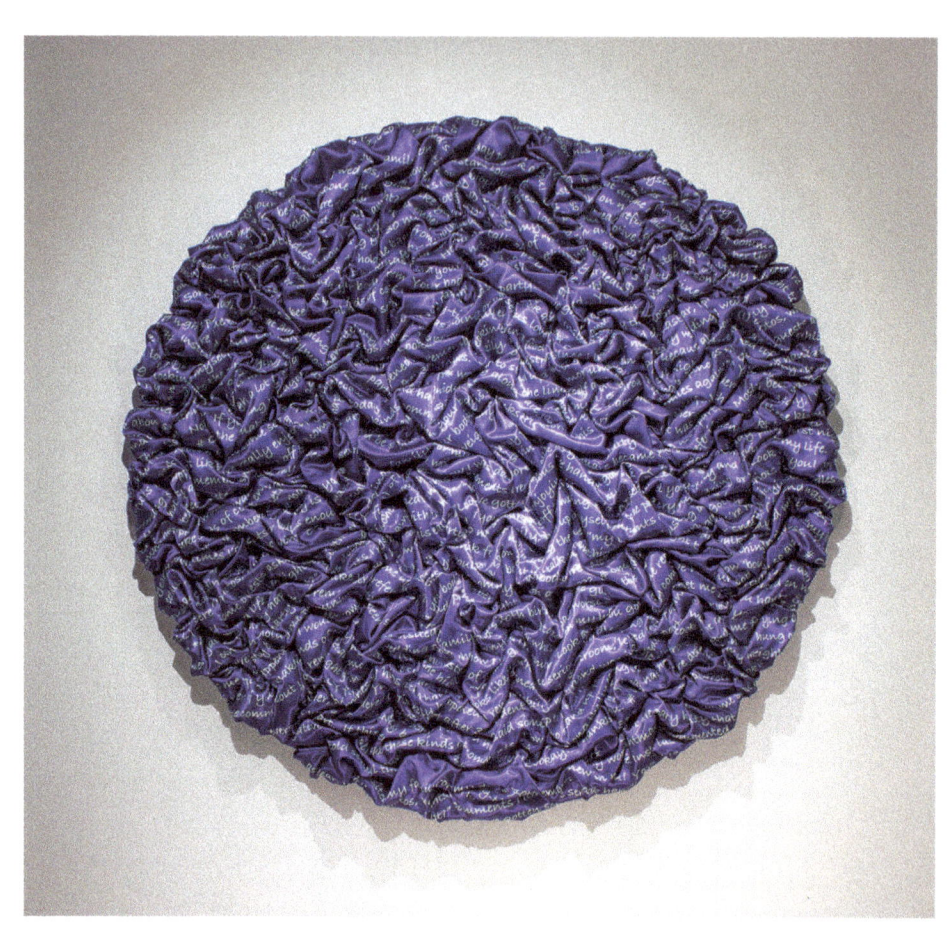

Katherine VAN DRIE | MFA 2021
I've Been Told (i)
Custom printed textile

ARTIST INDEX

ABRAMS, Deighton | MFA 2016 82
ANDERSON, Christina Z. | MFA 2005 58
ARMISTEAD, David | MFA 2013 85
BRIDGES, Laken | MFA 2014 21
BURCHINAL, Tanna | MFA 2014 67
BUSER, Zac | MFA 2000 52
CHAPP, Steven | MFA 1985 24
CLIFFORD, Dale | MFA 1989 22
DAY, Kym | MFA 2017 73
DENK-LEIGH, Maggie | MFA 1999 30
DENNIS, W. Cameron | MFA 1990 36
DOWELL-DENNIS, Terri | MFA 1990 38
DRESKIN, Jeanet | MFA 1973 12
EHLERS, Nancy | MFA 2008 62
EPP-CARTER, Marty | MFA 2009 54
FERGUSON, Mandy | MFA 2018 74
FLOYD, Haley | MFA 2018 66
GARLAND, Andrea | MFA 2019 72
GEORGE, Amy Holmes | MFA 2000 51

GORMAN, Jerry | MFA 1983 19
GRIER, Sue | MFA 2004 48
GUION, Glenda | MFA 1985 28
HILTON, John | MFA 2002 44
HORTON, Russ | MFA 1993 34
HOWELL, Shane | MFA 1997 35
HUTCHINSON, Jenny | MFA 2009 49
HUTTER, Kat | MFA 2006 42
IWAMURA, En | MFA 2016 70
JARRARD-DIMOND, Terry | MFA 1979 13
JOHNSON, Allison | MFA 2019 76
JOHNSON, Lori Brook | MFA 2021 89
KARGOL, Matthew | MFA 2005 53
KAWAR, Nina | MFA 2014 83
KELLER, Elizabeth | MFA 1992 31
KOZLOWSKI, Hanna | MFA 2010 68
LEE, Roger | MFA 2007 42
LEEBRICK, Gilbert | MFA 1989 20
LEEBRICK, Jacquelyn | MFA 1995 32

LINVILLE, Travis ǀ MFA 2003	59
LOGAN, Zane ǀ MFA 2011	84
LOU, Richard ǀ MFA 1986	27
MARKEL, Fleming ǀ MFA 1998	33
MARKS, Michael ǀ MFA 2010	69
MARTIN, Cecile ǀ MFA 1989	23
MCDONALD, Dan ǀ MFA 2006	63
MITCHELL-ROGERS, Jo Carol ǀ MFA 1986	25
MORTON, Carey ǀ MFA 2018	81
MUSICK, Amanda ǀ MFA 2018	80
O'CONNOR, Meghan ǀ MFA 2007	57
ORSELLI, Janet ǀ MFA 2001	61
PLUNKET, Chad ǀ MFA 2004	64
PRAYTOR, Blake ǀ MFA 1998	41
PRIDGON, Ashan ǀ MFA 2018	79
PRINCE, Alyssa Reiser ǀ MFA 2013	75
RABANAL, Ashley ǀ MFA 2020	88
REDMOND, Jeanée ǀ MFA 1981	21
RICHARDS, Courtney ǀ MFA 2009	60
RILEY, Owen ǀ MFA 2010	77
ROSS, Aubree ǀ MFA 2013	78
SELBY, Talbot Easton ǀ MFA 2006	56
SMITH, Blake ǀ MFA 2002	46
STONEKING-STEWART, Jennifer ǀ MFA 2007	45
SWISHER, Paula ǀ MFA 2001	50
TILLINGHAST, David ǀ MFA 1994	39
TOMBERLIN, Carrie ǀ MFA 2005	55
VAN DRIE, Katherine ǀ MFA 2021	90
WEST, Matt ǀ MFA 2002	47
WILLOUGHBY, Alan ǀ MFA 1983	26
WINGO, Winston ǀ MFA 1980	18
WOLFER, John ǀ MFA 1998	37
WOODWARD, Kristen ǀ MFA 1992	40
WOOTEN, Susan ǀ MFA 1977	15

© 2023 Clemson University

ISBN: 978-1-63804-108-5

DESIGN
Richard Jividen, TEN2design

EDITOR & PUBLICATION COORDINATOR
Valerie Zimany, Chair and Professor, Department of Art

PUBLISHER
The Department of Art at Clemson University with additional support from the College of Architecture, Art and Construction, Clemson University

DISTRIBUTION BY
Clemson University Press

WITH GRATITUDE *to our juror, Harriett Green, Deans Peterson and Lopes, Graduate Coordinators Thum and Detrich, Professor Emeritus Vatalaro, our MFA alumni and all involved for their contributions to elevate Clemson Visual Arts, and their support in the design and development of this catalog, exhibition and celebration.*

SPECIAL THANKS *to Dave Dryden, Associate Vice President of Brand Experience; John Eby, Public Information Director; Denise Woodward-Detrich, Director of the Lee Gallery; Meredith Mims McTigue, Clemson Visual Arts Marketing and Public Relations Director; and Lori Gugan, Administrative Coordinator*

www.ingramcontent.com/pod-product-compliance
Lightning Source LLC
Chambersburg PA
CBHW041920180526
45172CB00013B/1345